IMAGES
of America

BROOKHAVEN

IMAGES
of America

BROOKHAVEN

Valerie Mathis Biggerstaff
and Rebecca Chase Williams

ARCADIA
PUBLISHING

Published by Arcadia Publishing
Charleston, South Carolina

Printed in the United States of America

Library of Congress Control Number: 2017932817

For all general information, please contact Arcadia Publishing:
Telephone 843-853-2070
Fax 843-853-0044
E-mail sales@arcadiapublishing.com
For customer service and orders:
Toll-Free 1-888-313-2665

Visit us on the Internet at www.arcadiapublishing.com

*To the citizens of Brookhaven who voted to form a city in order
to have a government closer to the people and wanted to preserve
and build upon an already great community. —Rebecca*

*To my mom, Dorothy, who inspired my love for
DeKalb County history. —Valerie*

CONTENTS

ACKNOWLEDGMENTS

Many people have dedicated their time and energy to helping us gather these historic photographs. Eli Arnold, of the Oglethorpe University Philip Weltner Library, guided us through its many records to put together a collection of images that represent the importance of Oglethorpe to Brookhaven. Albert Martin, descendant of the Goodwin family, shared his records, memories and family photographs so that we could include this essential part of the history. Thank-yous also go to William Hardesty of the Georgia State University Archives and Fred Mobley of the DeKalb History Center for their help in researching their respective archives. John Dickerson was central to the success of this project, providing his professional photography expertise and helping us collect photographs from local sources. Thanks are also extended to the people with the churches and schools that searched their records and shared historical knowledge with us—but especially to Corinne Jordan Dodd, who shared her grandmother's photographs and records regarding the historic Brookhaven School.

INTRODUCTION

Along Peachtree Road, just north of Atlanta, is a community that has seen many changes through the years. It has been the setting for Creek Indians; farmers and mill owners; the reopening of a college; the first golf, home, and clubhouse development in the state; the training of World War I soldiers; and the development of homes, schools, parks, and businesses to create the unique city that is Brookhaven. One of the most significant changes took place in 2012, when the citizens of Brookhaven approved a referendum to become a city.

The first people here were members of the Creek Nation, who were forcibly removed following the 1821 Treaty of Indian Springs. Following a government-organized land lottery, new white settlers established homes and farms on this land. Others moved on and sold their property as more people moved to Georgia from Virginia and South Carolina. This early community was known as Cross Keys, but later adopted the name Brookhaven and for a while was a village, called North Atlanta.

The early community became known as Cross Keys because of the crossroads at Johnson Ferry Road and Ashford Dunwoody Road (then Cross Keys Road.) Cross Keys included a post office, stores, and a cotton gin. It is believed two early churches were near the crossroads. Mills were an important part of the early community and included Wallace Mill, Flowers Mill and Harts Mill. Nancy Creek and Peachtree Creek were essential to the settlement and the mills were built along the creeks. The road that is the most well known in Atlanta and possibly in Georgia, Peachtree Road, is central to today's Brookhaven. Peachtree Road was once a trail used by the Creeks. Later, it became a wagon road, connecting Fort Peachtree at Standing Peachtree and Fort Daniel at Hog Mountain.

Nancy and John Evins were part of one of the most prominent early families in Cross Keys. Nancy's name lives on, as one of the creeks that runs through Brookhaven carries her name; it was first known as Nance's Creek and later as Nancy's Creek. Salathel and Sarah Adams built a home on what is now part of Murphey Candler Park, and their family cemetery is at the end of a street in Nancy Creek Heights subdivision. Harris Goodwin came to the area with his new wife, Emily Dodgen Goodwin, and began working as a tenant farmer on the John Dobbs farm. Harris's father, Solomon Goodwin, came over from South Carolina and bought land from Dobbs. When the Atlanta & Charlotte Air-Line Railway came through around 1869, the stop adjacent to Goodwin land would become known as Goodwin's Crossing.

William Reeve was also an early settler, and his son James Reeve served as the second postmaster of Cross Keys, holding that position during the Civil War. Samuel House arrived in the area in the 1830s, and by 1845, he had built his home and owned hundreds of acres in the area around House Road (now Windsor Parkway), Peachtree Road, and Cross Keys Road. The home still stands today as the centerpiece of the Peachtree Golf Club. Another early settler was Thomas Humphries, who operated a gristmill.

Brookhaven was on General Sherman's path to Atlanta, and he stopped for a night at the Samuel House home. Union soldiers came down what is now Ashford Dunwoody Road and turned onto Peachtree Road, stopping at homes like the one owned by the Goodwins to take what supplies they needed. The burning of homes had not yet begun. A skirmish took place along Nancy Creek near the present-day location of Marist School.

Oglethorpe University, originally located in Midway, Georgia, was brought back to life on Peachtree Road in the early 1900s. The campus was damaged by Union soldiers during the Civil War and closed for many years. Dr. Thornwell Jacobs had a vision to reopen the college in Brookhaven. He diligently sought benefactors to see this dream fulfilled, and the beautiful campus now visible as one drives down Peachtree Road began with him.

The development of the Brookhaven Country Club and the neighborhoods that are part of Historic Brookhaven was a first for Atlanta and Georgia, as the first that combined a golf course and clubhouse with a neighborhood. The neighborhoods included Brookhaven Estates and Country Club Estates. The *Atlanta Constitution* published an article in 1910 about the upcoming club and described the attraction: "Automobilists are especially interested in the Brookhaven Country Club . . . the roads in all directions are splendid, and the club will be a most convenient stopping point during an afternoon's drive." The first homes near the club were primarily bought as summer or vacation homes. The name Brookhaven was not used before the establishment of the country club, so it could be assumed that this is the origin of the community's current name.

Camp Gordon, a World War I encampment, was built in 1917. The majority of the camp was in Chamblee, where DeKalb-Peachtee Airport is today, but portions of it were built in what is now Brookhaven. The camp's borders included Silver Lake and went as far out as the crossroads of Ashford Dunwoody Road and Johnson Ferry Road; the camp was adjacent to Oglethorpe University. In the year Camp Gordon opened, 232 Oglethorpe students joined the school's Army training corps. The soldiers of Camp Gordon regularly went on long hikes that took them into surrounding communities, including Brookhaven. The streetcar from Atlanta was extended past Oglethorpe University to Camp Gordon to help accommodate the soldiers. By 1921, Camp Gordon was abandoned and many of the buildings were demolished.

US Veterans Hospital No. 48 was set up in the early 1920s at the intersection of Osborne and Peachtree Roads in Brookhaven to help serve wounded World War I veterans. In anticipation of the United States entering World War II, Naval Air Station Atlanta was constructed in 1940 on a portion of the land that had been Camp Gordon. The naval air station continued to operate after World War II ended, until 1959, when it moved to Dobbins Air Force Base in Marietta.

Besides Brookhaven Estates, other neighborhoods were platted, including Fernwood Estates, on the east side of Peachtree Road.

The earliest school in Brookhaven was a one-room log schoolhouse known as Cross Keys School and established around 1886 on Osborne Road. The land for this school was donated by Justinian Evins, grandson of early settlers John and Nancy Evins—according to Ruby Mabry Evans, a member of another early family, the Mabrys. With the influx of more residents in the 1920s, the area needed a new school; Z.W. Jones and his wife, Margaret, recognized that need and founded the Brookhaven School. It was located along North Druid Hills Road just east of the railroad until the 1940s, when it was moved to where the Brookhaven Boys & Girls Club is today.

In the early days of Cross Keys, settlers attended churches in what became Chamblee. Nancy Creek Primitive Baptist Church, established in 1824, was the church of many families. Corinth Baptist Church and Prospect Methodist Church, located along Peachtree Road in Chamblee, were also churches of the early settlers. The House and Reeve families were involved in setting up the Methodist church. William Reeve, an early settler and Revolutionary soldier, is buried at Nancy Creek Primitive Baptist Church Cemetery. Today, the church is in Chamblee, and the cemetery—just across the road—is in Brookhaven.

The Samuel House home became part of the Ashford estate. William T. Ashford was one of the partners who sold land to Oglethorpe University and developed lots around Silver Lake. The Ashford Park community and Ashford Park School are named for his family. Ashford owned a nursery business, and his landholdings extended across Peachtree Road into what is now the Ashford Park neighborhood. The Samuel House home was later owned by the Caldwell family and then the Luckie family. In the 1940s, the land on which the house stands became the home of Peachtree Golf Club, created by Bobby Jones, who had begun to complain of crowds and long waits at East Lake Golf Club.

From 1924 until 1965, what is now Brookhaven was known as North Atlanta. A charter for the village of North Atlanta was issued by the City of Atlanta in 1924. City council meetings were sometimes held at the clubhouse of Ashford Park. Mayors were elected, but the community did not receive funds from DeKalb County to make improvements. A vote held in 1965 allowed voters to decide whether to continue under the old charter of North Atlanta, seek a new charter, or become part of unincorporated DeKalb County. The vote went to becoming part of unincorporated DeKalb County.

Several schools are part of Brookhaven today, and some date back to the 1950s. Ashford Park School was established in 1954, Woodward Elementary in 1958, and Montgomery Elementary in 1964. DeKalb Path Academy was once the Jim Cherry School, which opened in 1950. Before Cross Keys High School was built, local children attended Chamblee High School.

Another important school is Lynwood School, built in 1942 on Mae Avenue, which was part of the Lynwood Community, a community of black residents established in the late 1920s or early 1930s. In the 1950s, DeKalb County built a new school within the neighborhood. Children attended this school until 1968, when it was closed and they were told to attend other local schools. A group of black students who went to Cross Keys High School as the first integrators recently reunited to celebrate the momentous day, which was necessary for the future of Brookhaven and DeKalb County but a difficult day for the young students.

Brookhaven is home to 12 parks, some of which are on land with much history. Blackburn Park was once the location of a portion of Dr. C.C. Hart's mill business; later, it was home to military housing, and then Oglethorpe Apartments, before becoming a public park. When the apartments fell into disrepair, Ben Blackburn made the decision to establish a public park.

Brookhaven Park is on the land where Veterans Hospital No. 48 was once located. Murphey Candler Park was built on land once owned by pioneer Salathel Adams. Candler Lake is named for Scott Candler, the DeKalb County commissioner who agreed to build the lake, and Murphey Candler Park is named for Scott Candler's father, Charles Murphey Candler.

Briarwood Park was established in the 1950s, when John Earley wanted a park in the area where children could play baseball. Earley went to the county government and said, "If I get the land donated, will you build the park?" And they agreed. The land was donated by Gerard Jones and Hazel Fricke. Clack's Corner was set up by the Brookhaven Heights neighborhood in memory of Howard Clack, who had lived on the property since his birth in the 1920s.

Brookhaven incorporated in 2012 and has begun the work of improving all aspects of the city, including parks, roads, and services for the residents who live there. It is another beginning for this area, which includes just over 50,000 people—the new city of Brookhaven.

One

THE EARLY YEARS

Nancy Baugh Evins and her husband, John, were some of the earliest settlers in what is now known as Brookhaven. They settled along a creek that became known as Nance's Creek and, later, Nancy's Creek. One of the stories behind this name is that when John was looking for his wife, he would often find her down by the creek fishing or cooling her feet, with the implication being that she would rather be at the creek than doing household chores. John was buried on the land of the old homeplace, and Nancy is believed to be buried at Nancy Creek Primitive Baptist Church Cemetery. Nancy is pictured here with her daughter, Georgia. (DeKalb History Center.)

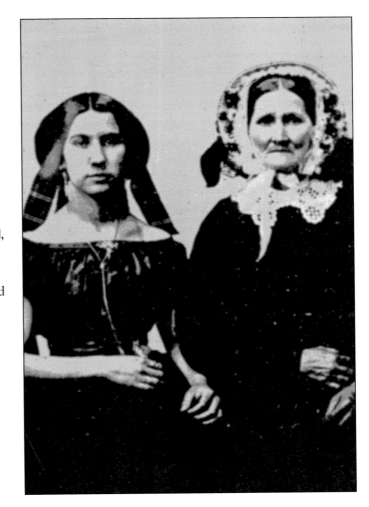

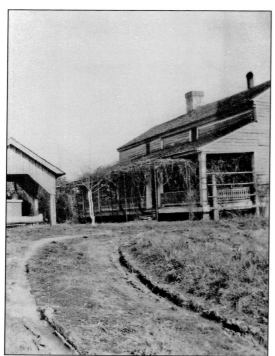

The Goodwin family were living in Laurens, South Carolina, when brothers Starling and Harris decided to travel to the Sixes, a gold-mining community now under Lake Allatoona in Georgia. Harris met and married Emily Dodgen in Forsyth County, Georgia, and they moved to the Cross Keys district of DeKalb County, where Harris worked as a tenant farmer for John Dobbs. Harris built a log cabin on the property, and it became a popular stopping place for travelers. This photograph of the Goodwin home in the early 1900s was taken at the original location at the corner of Peachtree Road and Decatur Road (now North Druid Hills Road). The house was moved in 1960 farther south on Peachtree Road and became known as the Solomon Goodwin Home, with a Georgia Historic Marker on the property. It was the oldest extant home in DeKalb County until development and high property taxes led to it being dismantled in 2016. (Albert Martin.)

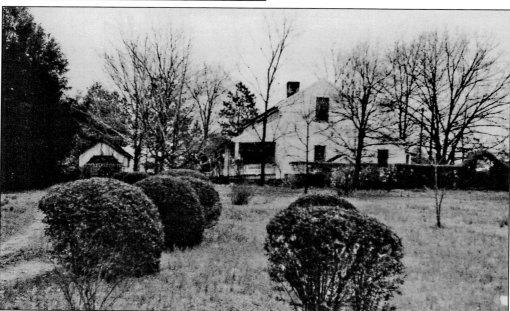

Harris Goodwin lived in a log cabin on the John Dobbs property and worked as a tenant farmer. He told his father, Solomon Goodwin, who still lived in South Carolina, about the good farming in Georgia. The elder Solomon's wife had recently died, so he sold his belongings and moved to Georgia. He then began purchasing property, including the land where Harris was working. Harris and Solomon Goodwin built their own log cabin, adding on to it through the years. (Albert Martin.)

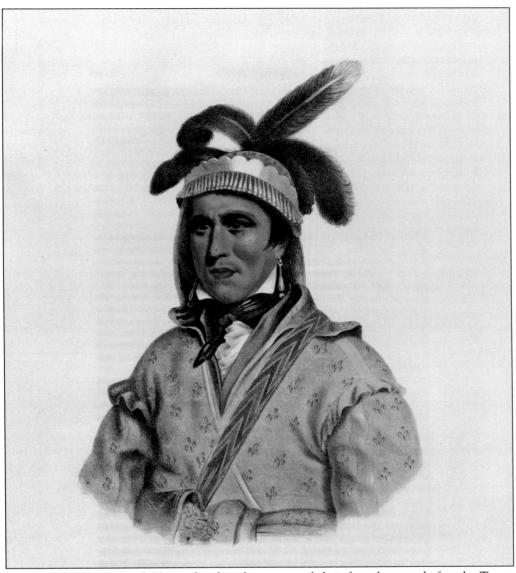

People of the Upper Creek Nation lived in this area until their forced removal after the Treaty of Indian Springs in 1821. What was once a trail of the Creek Nation later became a wagon road connecting Fort Peachtree at Standing Peachtree and Fort Daniel at Hog Mountain, and then the well-known Peachtree Road. When the Goodwins came to the area in the mid-1830s, there were still Creeks living in the vicinity who helped clear the land and build the house. This photograph features Creek chief Opothle Yoholo. (Library of Congress.)

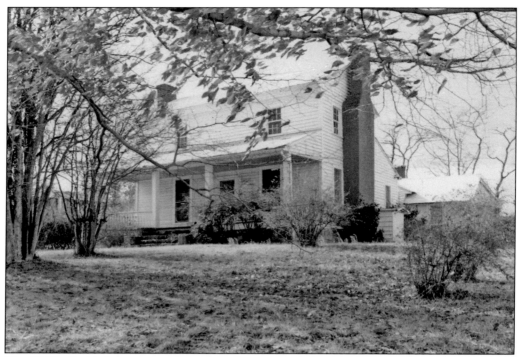

The Tullie Smith home was originally built around 1840, when her great-grandfather Robert Smith brought his family from North Carolina to Georgia. The story passed down from Tullie's grandmother was that she could see Atlanta burning during the Battle of Atlanta. The Smiths were related to the Mason family, whose name is still part of DeKalb County in Mason Mill Road (off Clairmont Road). Tullie was the last of the family to live in the historic residence. It was moved to the Atlanta History Center in 1972 thanks to the generosity of Mills B. Lane and C&S Bank. The area where the Tullie Smith house once stood is now part of the Executive Park office complex and was annexed into the city of Brookhaven in 2013. (DeKalb History Center.)

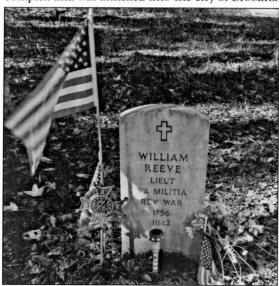

The Reeves were early settlers in what is now Brookhaven. William Reeve fought in the Revolutionary War and is buried at Nancy Creek Primitive Baptist Church Cemetery. His son James Reeve came to the area first and then encouraged his father to move here. James was one of the early postmasters for the area then known as Cross Keys. (Photograph by Valerie Mathis Biggerstaff.)

Francis Monroe Adams, pictured here at his home along what is now Dunwoody Club Drive, is one of the many descendants of Salathel Adams, who once owned the land where Murphey Candler Park is now located. Salathel was one of the justices of the peace for DeKalb County in 1844. The Adams family cemetery is now part of Nancy Creek Heights subdivision. There are many descendants of Salathel Adams still in the Atlanta area, including Richard Adams, who has campaigned for repair and upkeep of the family cemetery for many years. Among those buried in the cemetery are Salathel (1799–1862), Sarah Adams (1800–1896), and George W. Wilson, Confederate soldier, Company A, 10th Georgia Cavalry. (Richard Adams.)

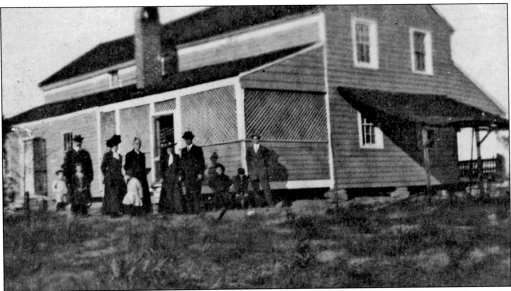

When Solomon Goodwin came to Brookhaven on the recommendation of his son, Harris, he purchased a portion of land lot 200, all of land lot 239, and half of land lot 238. This totaled 450 acres, which he bought from John Dobbs for $1,200. This photograph was taken in 1909, and the family members pictured are, from left to right, A.J. Martin, Albert Martin, Ralph Martin, Neoma"Oma" Childress Martin, Evelyn Martin, Permelia Goodwin Childress (Neoma's mother), Neoma's sister and brother-in-law, Neoma's two nephews, and Neoma's younger brother. In 1906, A.J. formed the Goodwin's Home Club to help preserve the old home and property; ten Goodwin family members paid $120 each to buy the home back after it had been out of the family since 1889. Family members would arrive in cars or carriages to picnic and maintain the cemetery. (Albert Martin.)

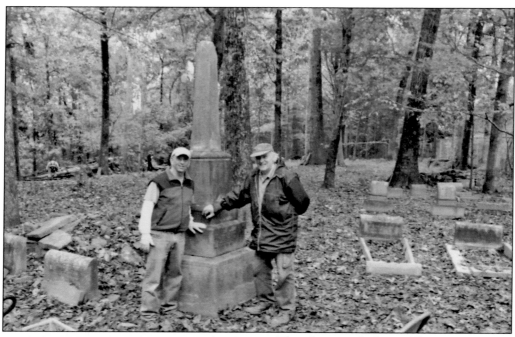

The Press and People regard THE CHRISTIAN INDEX the best Advertising Medium in the South.

CRO		CRY
four times a week. James A. Hall, P. M.	Polk J. H., teacher	
Cartledge G. H. Rev., Presbyterian	Redling J. W., constable	
Crane T., miller	Walker H. H., lawyer	
Crane T. J., physician	Walker & Elliott, cotton gin	
Crane & Legrand, genl store		
Cromer George, saw mill	**CROSSVILLE.**	
Cromer J. D., surveyor	*Dawson County.*	
Haley J. L., school teacher	Claiming a population of 25, is located 7 miles southeast of Dawsonville. No post office.	
James L., wagonmkr		
Nelms G., blacksmith		
Presley J., cabinet mkr	**CROW HARBOR.**	
	Camden County.	

CROSBY.
Habersham County.

This village lies 4 miles south of Clarkesville; is not a post office, and has about 25 inhabitants.

A little hamlet 8 miles north of Bayley. Without postal advantages. It claims a population of 25.

CROSS ANKER.
Campbell County.

An unimportant settlement, numbering some 20 people, 5 miles north east of Campbellton, and about 7 north of Fairburn. Without postal facilities.

CROSS CREEK.
Pulaski County.

Is situated 10 miles southeast of Hawkinsville. It is not a post office, and has about 25 inhabitants.

CROSS KEYS.
DeKalb County.

Goodwin's—A. & C. A-L. Ry.—one and one quarter miles distant is the depot and station for this place. Doraville, 3 miles distant, is the nearest express office. It is 9 miles north of Decatur, the seat of justice, and 12½ from Atlanta. Nancy's creek furnishes power for operating a mill. The place has two churches—Methodist and Baptist—one common school, and steam cotton gins. Cotton and wood form the chief exports. About 140 bales cotton shipped per annum, most of which is carried to Atlanta by wagon. Population within a radius of 2 miles, near 400. Mail daily.
G. L. Humphries, P. M.

Hart C. C., physician
Holbrook J. A., justice
Holbrook W. C. Rev., Methodist
Humphries G. L., grist mill

CRYSTAL SPRING.
Floyd County.

Thirteen miles northwest of Rome, the county seat and usual point of supplies, via which it is 93 miles from Atlanta. The little village of 80 inhabitants is beautifully located in the healthiest portion of the State, and near one of the finest limestone springs in northwestern Georgia. A small stream known as the Arenachee creek affords power to operate a gin, grist and saw mills. The place also contains three churches—Methodist Missionary Baptist and Presbyterian—and a good high school. Cotton, flour and grain are exported. Mail, daily by hack. Abner Echols, P. M.

Echols Abner, grist mill
Espy Joseph, carpenter
Espy J. B., justice
Gaines R., constable
Grace William, shoemkr
Grace William Jr., constable
Greer Benjamin, teacher
Hendricks William Rev., Baptist
Henson J. T., miller
Jackson A., shoemkr
Joiner J. J., teacher
Lindsey Marion, carpenter
Marshall A. A., teacher
Massey John, miller
Massey J. W., carpenter
Murdock J. R., brick mason
Selmon J. W., justice
Selmon W. L., physician
Selmon W L. Jr., genl store
Story P. M., blacksmith
Towns Henry, miller
Wright Charles Rev., Baptist

This photograph shows Albert Martin (right), descendant of Harris Goodwin, and local historian Ren Davis standing by Harris Goodwin's grave monument. The grave was relocated to Nancy Creek Primitive Baptist Church Cemetery after being at the old Goodwin homeplace for many years. When Harris and other Goodwin family members were reinterred at Nancy Creek Primitive Baptist Church Cemetery, they were returning to their original place of burial; they were moved to the Goodwin property in the 1960s due to vandalism at the church cemetery. (Photograph by Valerie Mathis Biggerstaff.)

This page of the *Sholes' Georgia Gazetteer and Business Directory* for 1879 and 1880 lists Cross Keys among the villages within DeKalb County. The description summarizes the location of the community and what type of businesses are located there. It also advises that 400 people live there, and approximately 140 bales of cotton are shipped mostly to Atlanta each year. Some of the names listed are C.C. Hart, physician; G.L. Humphries, grist mill; J.A. Holbrook, justice; and Rev. W.C. Holbrook, Methodist minister. (Digital Library of Georgia.)

Two

IMPACT OF THE CIVIL WAR

This map, drawn by Charlie Crawford, president of the Georgia Battlefields Association, shows the movement of the Union troops through Brookhaven (Old Cross Keys) in 1864. Gen. John Schofield's 23rd moved from Sandy Springs by way of Johnson Ferry Road towards Old Cross Keys. From there, Schofield's troops veered to the right at Peachtree Road and then left along what is now Briarwood Road. Gen. G.M. Dodge's 16th came from Providence (Dunwoody) and followed the path of today's Ashford Dunwoody Road, meeting up with the 23rd at Old Cross Keys. From this point, the 23rd marched along what is now Chamblee Tucker Road and Shallowford Road on their way to Decatur. (Charlie Crawford.)

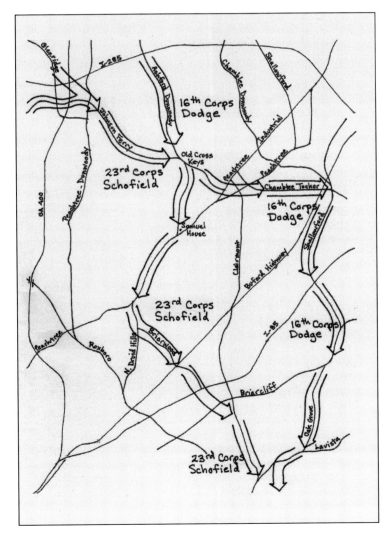

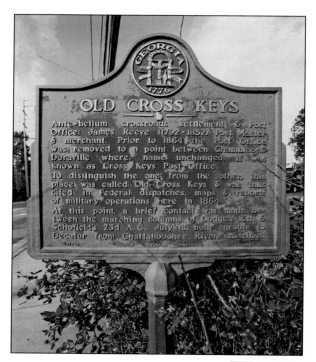

This marker sits at the old crossroads of Johnson Ferry Road and Cross Keys Road (now known as Ashford Dunwoody Road). Old maps reference Cross Keys, and Civil War dispatches refer to the area as Cross Keys. Gen. William T. Sherman refers to Cross Keys when describing where he spent the night on July 18, 1864, when he stayed at the Samuel House home. The post office and other businesses were once at this crossroads, and James Reeve (1792–1852) was postmaster and a merchant. On July 18, Gen. G.M. Dodge's 16th and Gen. John Schofield's 23rd marched through this crossroads on their way to Decatur. (Photograph by John Dickerson.)

Maj. Gen. James. B. McPherson of the Union army and leader of the Army of the Tennessee, under the direction of Gen. William T. Sherman, issued Special Field Order No. 69. This order detailed the movement of the 15th Army Corps, commanded by Maj. Gen. John A. Logan, which was instructed to head from Roswell toward Providence Church (now Dunwoody) and take the road to Cross Keys. Gen. G.M. Dodge of the 16th Army Corps was to follow the 15th and head towards Cross Keys and Nancy Creek. Maj. Gen. F.P. Blair and Brigadier General Garrard were also to head towards Cross Keys and Nancy Creek. The Battle of Peachtree Creek took place on July 20, 1864. On July 22, the Battle of Atlanta occurred, and General McPherson was killed. McPherson Avenue in Atlanta was named for him. (Library of Congress.)

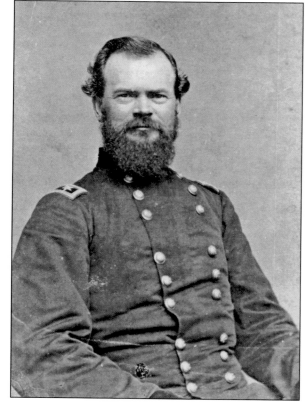

This Georgia Historical Marker is located along Ashford Dunwoody Road near Marist School. A skirmish between the 9th Illinois Mounted Infantry and Col. George Dibrell's brigade of Wheeler's cavalry occurred in this area on July 17, 1864. Dodge's troops spent the night on either side of Nancy's Creek. (Photograph by John Dickerson.)

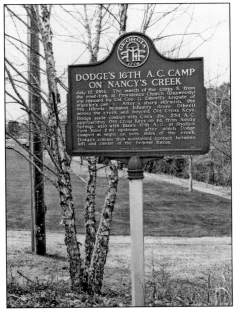

On the night of July 18, 1864, Gen. William T. Sherman spent the night in this structure, the home of Samuel House. General Sherman issued a dispatch on that day and wrote on it that his location was near Cross Keys, and he also wrote a letter that specifies he was at the Samuel House home. (Georgia State University.)

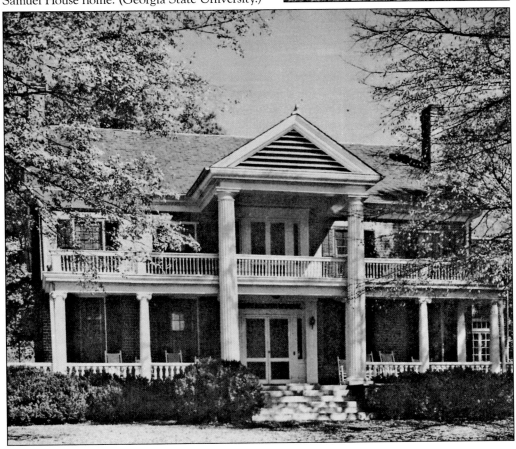

A VERBATIM COPY OF THE MILITARY DISPATCH SENT BY GENERAL
W. T. SHERMAN TO GENERAL J. B. MCPHERSON WHILE THE FORMER
WAS STOPPING AT THE HOME OF SAMUEL HOUSE IN DEKALB COUNTY,
GEORGIA, JULY 18, 1864. THIS MESSAGE CAN BE FOUND ON
PAGES 175 & 176 OF SERIES I, VOLUME XXXVIII, PART V, ATLANTA
CAMPAIGN, OFFICIAL RECORDS OF THE UNION AND CONFEDERATE
ARMIES.

HDQRS. MILITARY DIVISION OF THE MISSISSIPPI
In the Field, on Peach Tree Road, July 18, 1864

General McPherson:

I am at Sam. House's, a brick house well known, and near Old Cross Keys.
A sick negro, the only human being left on the premises, says we are eleven
miles from Atlanta, five from Buck Head, and a sign board says ten miles
to McAfee's Bridge and eleven to Roswell Factory. At this place the main
Buck Head and Atlanta road is strongly marked and forks, the right-hand
looking north going to McAfee's, and the left to Roswell Factory. This
left-hand road forks one mile from here, at Old Cross Keys, the main road
going to Roswell and left-hand to Johnson's Ferry. The latter is the road
traveled by us. I suppose all of Thomas' troops are at Buck Head, with
advance guard down to Peach Tree Creek. I think I will move Schofield one
mile and a half toward Buck Head, where the negro represents a road to
Decatur and forward on that road a mile or so. I think Sam. House's is
not far from the northwest corner of lot 273, and if I move him as contem-
plated he will be to-night about 202,203. On our map a road comes from
the direction of McAfee's toward Decatur, and if you can find position
about 192,191 it would best fulfill my purpose, but be careful to order
Garrard to break the road to-day or to-night and report result. I will
stay here or down at the forks of the road to-night. Schofield encountered
nothing but cavalry, about 500, according to the negro's report, and all
retreated toward Atlanta. Tell Garrard that it will be much easier to break
the telegraph and road to-day and night than if he waits longer. This negro
says there is a road leading to Stone Mountain from a Mr. Lively's, on the
Decatur road, on which I suppose you to be. At any rate I will be here till
evening and would like to hear from you.

Yours,

W. T. SHERMAN,
Major-General.

This document shows the dispatch that Gen. William T. Sherman wrote outlining the plans for the
following day when he was located at the Samuel House home on July 18, 1864. The House family
had left their home in anticipation of the arrival of Union troops. (Peachtree Golf Club.)

Gen. William Tecumseh Sherman spent the night at the home of Samuel House on July 18, 1864, as his Union troops had recently crossed the Chattahoochee River and were marching towards Atlanta. He wrote that night, "I am at Samuel House's, a brick house, well known and near Cross Keys." This photograph of General Sherman was taken in September of 1864 at Fort 7, built by the Federals in Atlanta. (Library of Congress.)

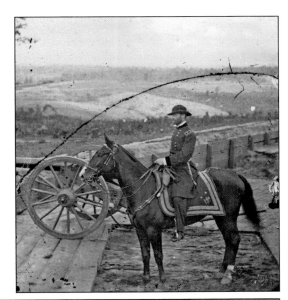

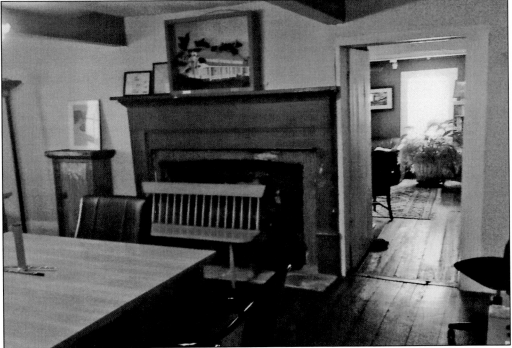

When Union troops marched through Old Cross Keys, they stopped at the Goodwin home in search of food and supplies. The soldiers cut a piece out of the mantel seen in this photograph to use for kindling. Goodwin descendants know of three theories as to why the Union soldiers did not damage the home: The first is that gunpowder was thrown on the floor, but slaves who were seeking shelter in the home convinced the Union soldiers not to burn it; the second is that General Sherman had not yet ordered the burning of homes; and the third is that a mother and newborn were in the home. Albert Martin believes that during the Civil War, the home was occupied by members of the Reeve family rather than Goodwins. (Albert Martin.)

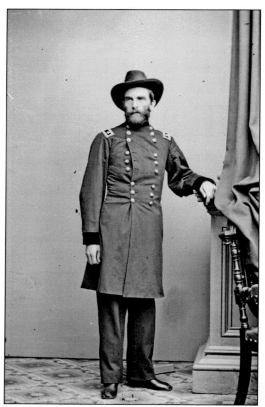

This portrait is of Maj. Gen. G.M. Dodge. General Dodge and his 16th Army Corps were ordered to follow the 15th on the Cross Keys Road to Nancy's Creek. On July 18, 1864, the 16th headed south along what is now Ashford Dunwoody Road from its camp along Nancy Creek (near the Marist School) and briefly made contact at Old Cross Keys with the 23rd Corps headed southeast along Johnson Ferry Road. The 16th then marched southeast along Johnson Ferry Road and what is now Chamblee Tucker Road before meeting with the 15th and 17th at Rainey's Plantation, located in the triangle formed where Shallowford Road and Chamblee Tucker Road intersect. A historical marker there describes the event and indicates General Dodge's 16th continued one mile south after the meeting before camping for the night. (Library of Congress.)

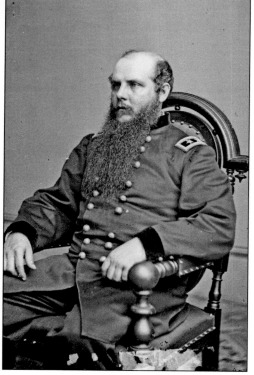

Maj. Gen. John Schofield, pictured here, and his 23rd Corps were across the river and on the high ground along what is now RiverEdge Parkway and Heards Ferry Road, north of Interstate 285. From there, they split off into two groups, with one division heading south along Long Island Drive before turning east on Mount Paran Road while the other division continued east through Sandy Springs on the current Mount Vernon Highway before turning southeast on Johnson Ferry. The two divisions met at what is now known as Pill Hill and crossed into what is now the city limits of Brookhaven, then headed for Old Cross Keys (now the intersection of Johnson Ferry Road and Ashford Dunwoody Road). (Library of Congress.)

Three

THE REBIRTH OF OGLETHORPE UNIVERSITY

Dr. Thornwell Jacobs dreamed of attending Oglethorpe University as a young boy. The college was originally located in Midway, Georgia, near Milledgeville, but had been damaged and then forced to shut down after the Civil War. In 1912, Dr. Jacobs began a campaign to reopen Oglethorpe, calling it "The Atlanta Campaign." He had come to Atlanta a few years earlier to work for Agnes Scott College. Dr. Jacobs found 50 Atlantans who pledged $1,000 each toward the campaign, including Coca-Cola founder Asa Candler. He also solicited $5,000 from local developer Samuel Inman and $50,000 from newspaper mogul William Randolph Hearst. Hearst had purchased a struggling newspaper called the *Atlanta Georgian*. (Philip Weltner Library Archives, Oglethorpe University.)

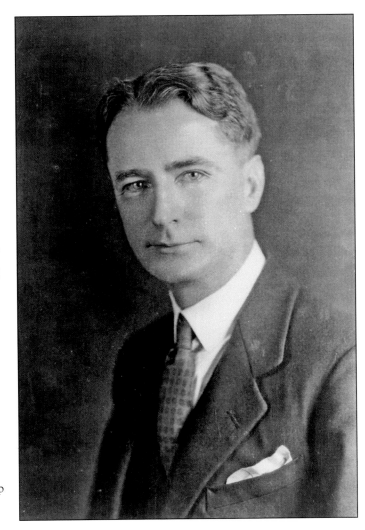

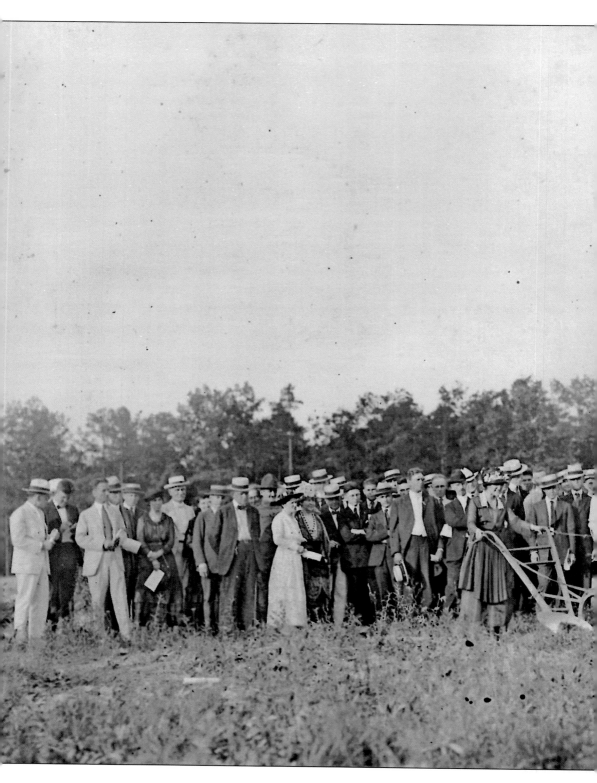

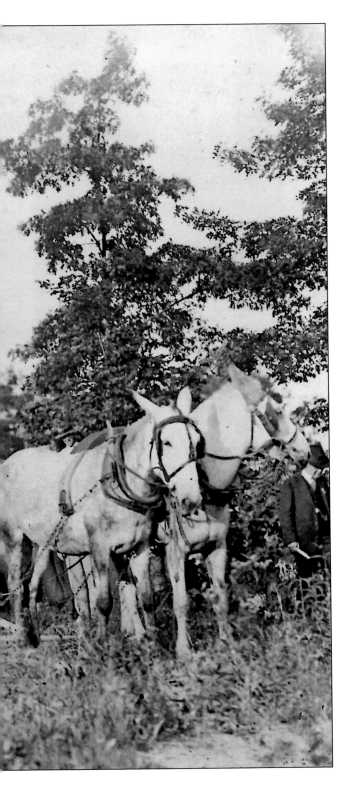

The ground-breaking ceremony for Lupton Hall on June 11, 1919, was a grand occasion for Dr. Thornwell and Maud Jacobs, and others gathered to celebrate the day. Dr. Jacobs's dream of reopening Oglethorpe University had become a reality. He began his campaign to revive Oglethorpe by searching for investors. He obtained promises from 50 prominent Atlantans to donate $1,000 each. Ivan Allen chaired the committee for fundraising. William Owen, president of Silver Lake Park Company, was a fundraising subcommittee chairman. W.T. Ashford, who had purchased the old Samuel House estate, was owner of the Silver Lake Park Company and was on Oglethorpe University's Board of Founders. The college librarian is holding the plow. (Philip Weltner Library Archives, Oglethorpe University.)

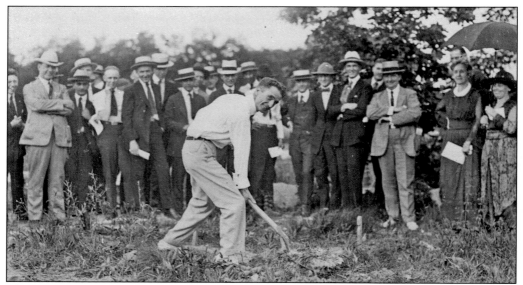

This 1919 photograph shows Dr. Thornwell Jacobs scooping the first shovel of dirt for the construction of Lupton Hall on Oglethorpe University's new campus. The college was originally located in Midway, Georgia near Milledgeville. Dr. Jacobs began a campaign to rebuild the college on land along Peachtree Road just north of Atlanta. He served as president of the university from 1915 until 1943. (Philip Weltner Library Archives, Oglethorpe University.)

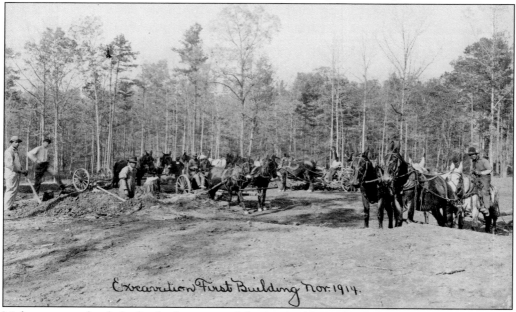

Mules were used to help dig the basement of the first building of Oglethorpe University in 1914, when it reopened on the outskirts of Atlanta in the area later known as Brookhaven. The first building was known as the Administration Building but was renamed Hearst Hall in 1948. It was named in memory of Phoebe Hearst, the mother of William Randolph Hearst, an early generous donor to the university. Oglethorpe University is named for Gen. James Edward Oglethorpe, the founder of the colony of Georgia. (Philip Weltner Library Archives, Oglethorpe University.)

In 1914, construction began on Oglethorpe's Administration Building. The architects of Oglethorpe University were Morgan, Dillon, and W.T. Downing. The building contractor was W.E. George. The buildings were designed to be similar to those of Corpus Christi College at Oxford, which James Oglethorpe attended. The Atlantic Stone Company and William Hurd Hillyear of that company donated 2,500 tons of Elberton blue granite for the construction of the new university. (Philip Weltner Library Archives, Oglethorpe University.)

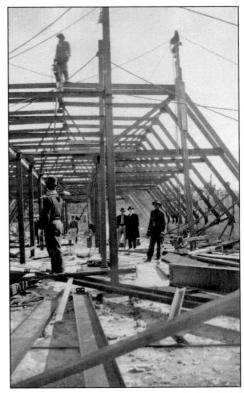

Lupton Hall, pictured here in 1927, was the second building constructed at the new Oglethorpe University on Peachtree Road in Brookhaven. Lupton Hall is named for John Thomas Lupton (1862–1933), who initially donated $10,000 for the campus and then $50,000 for this second building. Dr. Thornwell Jacobs met Lupton, owner of the southern franchise of the Coca-Cola Bottling Company, at First Presbyterian Church of Chattanooga. (Philip Weltner Library Archives, Oglethorpe University.)

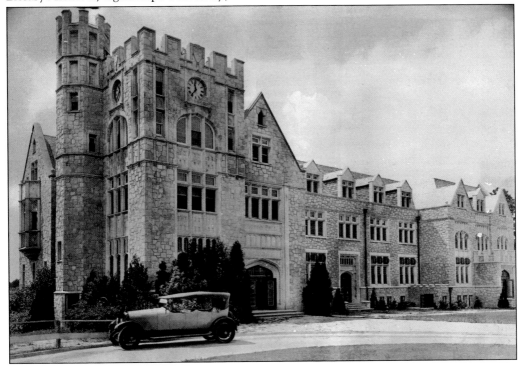

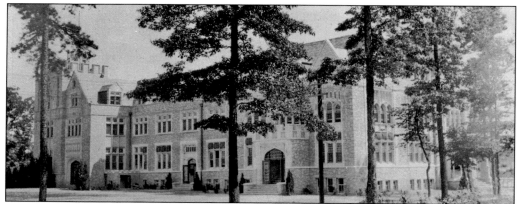

In 1922, Grace Josephine Lesh of Boston, Massachusetts, donated the Lesh Chimes, which are located at the top of Lupton Hall and still ring to this day. There were initially four chimes, with a fifth added in 1929 when a gift was made by Mrs. J.M. High of Atlanta. The inscription on the largest chime reads, "Given by Grace Josephine Lesh, that the hours at Oglethorpe might be filled with music and harmony." Five more chimes were added to the carillon in 1929 (plus twenty-five more in 1972). This photograph of Lupton Hall is from 1930. (Philip Weltner Library Archives, Oglethorpe University.)

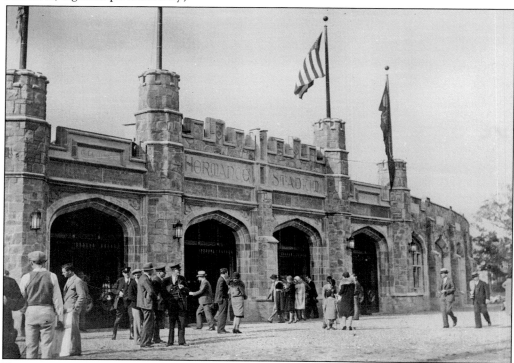

Hermance Stadium at Oglethorpe University was constructed in 1929 thanks to a generous $50,000 donation from Harry P. and Sibyl Hermance. The stadium was constructed of granite, like the other buildings of Oglethorpe. Even though the stadium was not completed as planned due to the Great Depression (and remains seven-eighths incomplete), it has been an integral part of Oglethorpe University through the years. The stadium is listed in the National Register of Historic Places. (Philip Weltner Library Archives, Oglethorpe University.)

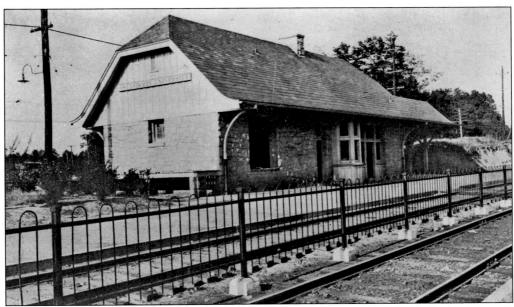

Oglethorpe Station was built across the road from Oglethorpe University in 1917, which Thornwell Jacobs referred to as the year of transportation. This was the year that Camp Gordon, a World War I camp, was constructed a little farther north near Peachtree Road in Chamblee. It was at this time that both Peachtree Road and the streetcar line were extended to reach the camp. An early engineer for the train was Ike Roberts, who took over as engineer after 40 years working on the Roswell Railroad. The station was built in the same style and with the same type of granite as the campus buildings. (Philip Weltner Library Archives, Oglethorpe University.)

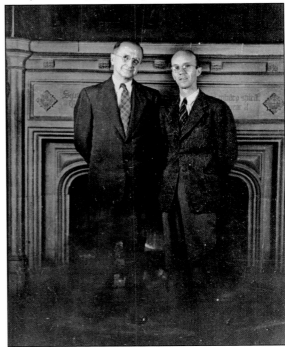

Dr. Philip Weltner (left) came to Oglethorpe University following World War II and worked to help it recover from those difficult times. He served as president of the university from 1944 until 1953. Dr. Weltner first came to Georgia from New York with his parents and attended the University of Georgia. He received his law degree from Columbia University. The Philip Weltner Library on the Oglethorpe campus is named in his honor. George Seward (right) was a philosophy professor and vice president who worked under Dr. Weltner. Seward served as interim president of Oglethorpe University three times during his career. (Philip Weltner Library Archives, Oglethorpe University.)

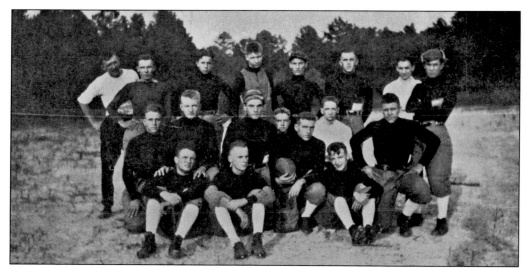

The Oglethorpe varsity football team of 1917–1918 played at the Atlanta Crackers baseball field on Ponce de Leon Avenue and at Georgia Tech's Grant Field before Oglethorpe had a stadium. The early football teams played schools such as Universities of Alabama, Florida, and Georgia, Furman University, and Georgia Tech. Frank Anderson was the first football coach at Oglethorpe University. (Philip Weltner Library Archives, Oglethorpe University.)

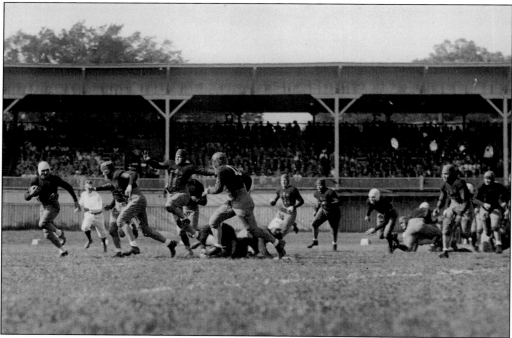

This action shot of the Oglethorpe University football team was taken during the 1938–1939 season. At this point, the partial completion of Hermance Stadium gave the team a place to play. The stock market crashed before the stadium could be completed, and the uncompleted stadium is still used today. The donor of $50,000 for the stadium construction was Harry Hermance, an executive of Woolworth's. (Philip Weltner Library Archives, Oglethorpe University.)

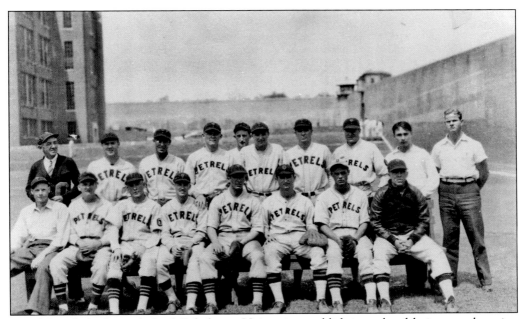

Coach Frank Anderson helped Oglethorpe University establish its early athletic teams by going into the community and finding young men he thought would make good members of the team. A young man plowing a field could make an excellent baseball player. This photograph features the 1938–1939 baseball team. Coach Anderson is at far left in the second row. (Philip Weltner Library Archives, Oglethorpe University.)

The Oglethorpe University basketball team of 1938–1939 is pictured here. The mascot of Oglethorpe University is the Stormy Petrel. Dr. Thornwell Jacobs chose the seabird as the mascot because the bird dives in and out of crashing ocean waves. (Philip Weltner Library Archives, Oglethorpe University.)

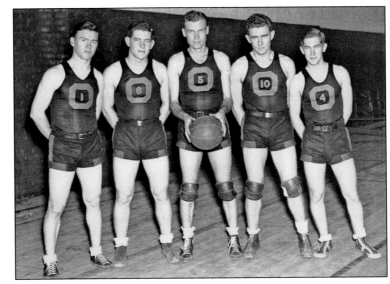

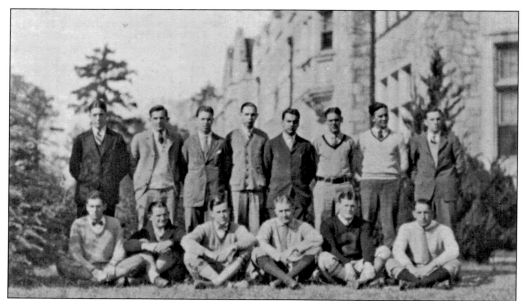

Dr. Thornwell Jacobs was determined to bring prestige to Oglethorpe University through the development of the athletics programs. This early photograph of the men's golf team is from 1924 or 1925. (Philip Weltner Library Archives, Oglethorpe University.)

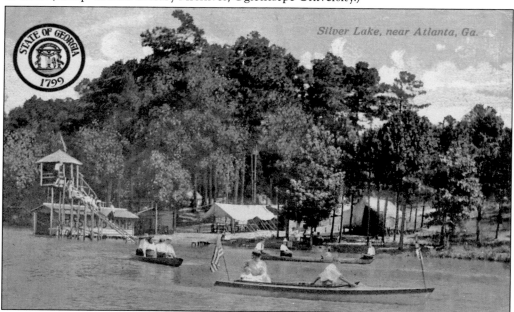

This 1913 postcard of Silver Lake shows that it was a destination for Atlantans during that time. The Silver Lake Park Company built the 28-acre lake in 1911 as part of a plan for it to be the center of a real estate development. The postcard depicts people swimming at a dock, canoeing, and generally enjoying the beauty of the lake. Oglethorpe University students were able to use the lake as part of an arrangement. Later, the lake was purchased by William Randolph Hearst for the university. It became known as Lake Phoebe, named for William Randolph Hearst's mother. (Ren Davis.)

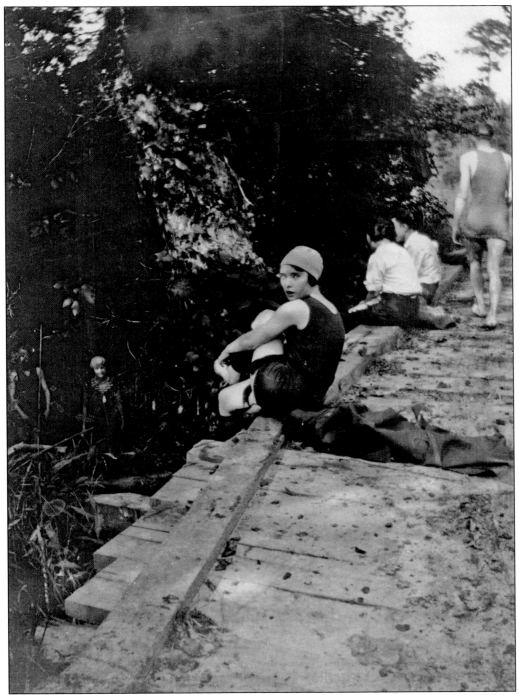

The Atlanta History Center has this photograph in its Margaret Mitchell Collection. She is pictured here while swimming with friends at Silver Lake. This was most likely during the time period depicted in the postcard on the previous page, the early 20th century, when the lake was a destination for people in Atlanta. (Atlanta History Center.)

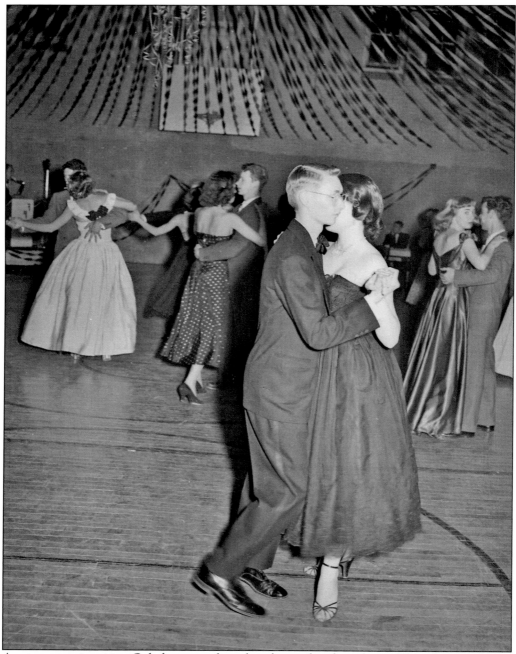

As at most universities, Oglethorpe students loved to gather for a dance. This photograph was taken at the "Black and White Dance" held on April 6, 1951. (Philip Weltner Library Archives, Oglethorpe University.)

Martha Mason Bator is pictured here descending the stairs in her ball gown. She is dressed for the Christmas formal held on December 8, 1950. (Philip Weltner Library Archives, Oglethorpe University.)

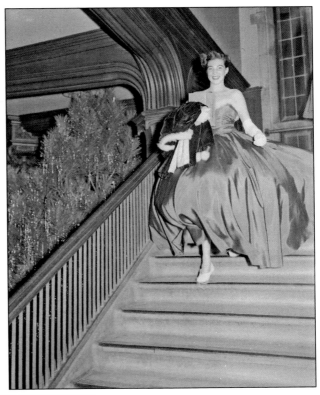

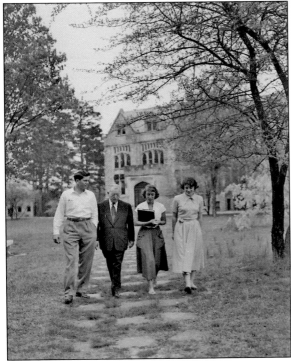

Martha Mason Bator, class of 1953, and Edmund Bator, class of 1951, contributed many 1950s photographs to Oglethorpe University. Edmund Bator worked as a photographer for the *Yamacraw* yearbook while he attended Oglethorpe. He took this photograph of an unidentified professor and students in 1950. (Philip Weltner Library Archives, Oglethorpe University.)

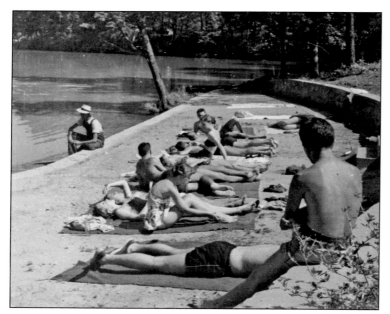

Here, Oglethorpe University students enjoy relaxing by Silver Lake in 1950. At that time, the lake was known as Lake Phoebe, named for the mother of William Randolph Hearst. The Hearsts were benefactors of the university dating back to when Hearst owned an Atlanta newspaper, the *Atlanta Georgian*. (Oglethorpe University, photograph by Edmund Bator.)

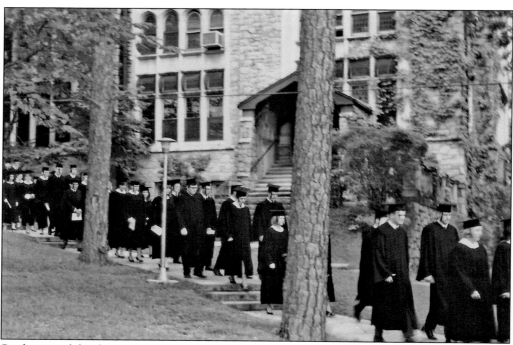

Students and faculty pass in front of Lupton Hall at Oglethorpe University in June 1967. This photograph was taken on Tom Reilly's graduation day, and he is toward the front of the line of students. The Reilly family moved to Brookhaven in 1953. Tom attended Our Lady of Assumption School, Cross Keys High School, and Oglethorpe University. Just one year after this picture was taken, Tom volunteered for the military and was sent overseas to Vietnam. (Photograph by Naomi Reilly.)

Four

HISTORIC HOMES AND NEIGHBORHOOD LANDMARKS

This turn-of-the-century photograph of descendants of Solomon Goodwin and Harris and Emily Goodwin was taken when the home was located at the intersection of Peachtree Road and the Old Decatur Road (now North Druid Hills Road.) Sometime between 1839 and 1842, additions were made to the home to accommodate the growing family. A kitchen porch and front porch were added, then a parson's room and a second story. More improvements were made in 1852 after Harris Goodwin inherited the home and property from his father. (Albert Martin.)

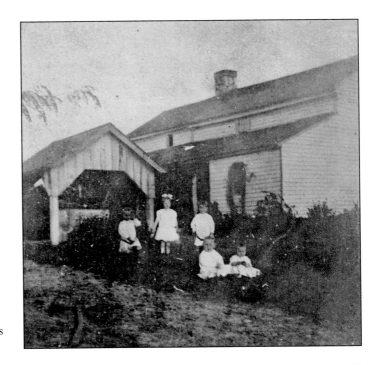

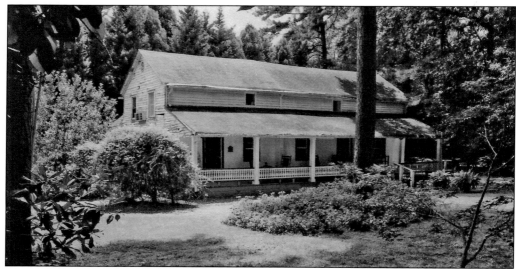

The Atlanta & Charlotte Air-Line Railway came through in April 1869, and Harris Goodwin deeded a right-of-way to the railroad for $5. Railroad timetables and older maps indicate there was a Goodwin's Station or Goodwin's Crossing. This photograph was taken after the Goodwin home was moved in 1960 from its original location at the southeast corner of North Druid Hills Road and Peachtree Road to 3931 Peachtree Road and used for business space. North Druid Hills Road was once known as Old Decatur Road, as it led to Decatur. Goodwin died in 1892. His obituary states that he was "one of the oldest and best known residents of DeKalb County, he was a man of many friends and his life was one of usefulness." (Albert Martin.)

A.J. Martin, a descendant of Harris Goodwin, is pictured here on the front porch of the Goodwin home around 1909. Martin established the Goodwin's Home Club to help protect and preserve the home and cemetery and asked all of the family to participate. His son, grandson, and great-granddaughters continued that tradition for many years through a new group they formed, the Goodwin Historic Society. Although the home has been disassembled and the property sold, there is hope that a new Brookhaven location will be found and the Goodwin home will return. (Albert Martin.)

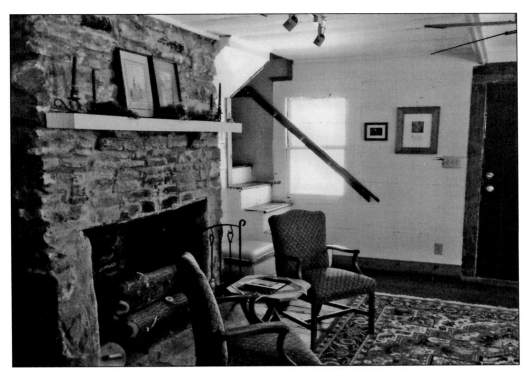

Harris Goodwin first came to this area in the 1830s, followed by his father Solomon Goodwin. The earliest church in the community was Nancy Creek Primitive Baptist Church, and Solomon Goodwin served as secretary of the church. This photograph is of the interior of the Goodwin home; behind the walls of this house were the walls of the original log cabin. (Albert Martin.)

This view inside the Goodwin home shows the front stairs. The home was open for tours on Sunday afternoons for several years. Albert Martin has gathered and maintained the historical records of the Goodwin home. An extensive archive is available at the DeKalb History Center. (Albert Martin.)

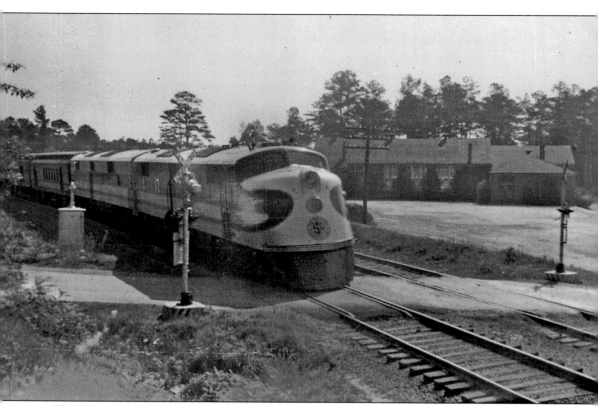

This photograph was taken from the Goodwin residence and shows the home's view of the railroad and the Brookhaven School. Old maps show the names Goodwin's and Goodwin's Crossing in this area; however, no station was ever built at the stop. Harris Goodwin sold the right-of-way for the Atlanta & Charlotte Air-Line Railway to pass through his property in 1869. The railroad later was the Southern Railway and is now Norfolk Southern Railway. (Albert Martin.)

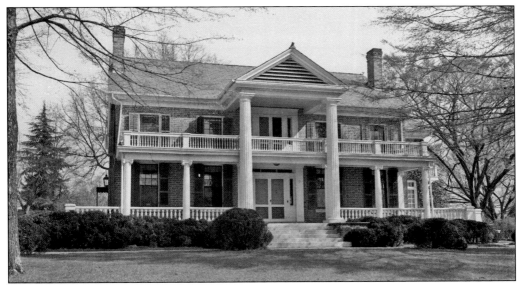

This home located at the corner of Peachtree and Ashford Dunwoody Roads was built by Samuel House in the 1850s. House owned several hundred acres in the area, and Windsor Parkway was once known as House Road. Other owners of the property have included the Luckie, Ashford, and Caldwell families. Today, the home is part of the Peachtree Golf Club. Historian Franklin Garrett wrote to Bobby Jones about the name of the club, suggesting that Cross Keys Golf Club or Cross Keys Country Club would have been a better name. (Georgia State University.)

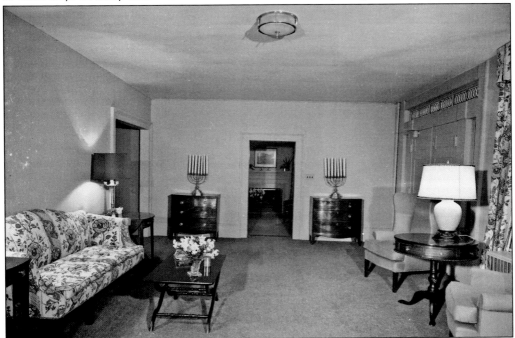

This 1940s photograph of the Samuel House home shows how it looked when it became part of the Peachtree Golf Club. This is the front parlor room. (Georgia State University, Lane Brothers Collection.)

The Samuel House home was acquired in 1903 by W.T. Ashford and became known as Southlook. In 1921, Ashford began a nursery business on the property. When the Ashford family owned the property, it included 240 acres and their business, Ashford Park Nurseries. This advertisement is in one of the Oglethorpe University *Yamacraw* yearbooks. The name "Ashford" lives on today in Ashford Park neighborhood, Ashford Park School, and Ashford Dunwoody Road. (Philip Weltner Library Archives, Oglethorpe University.)

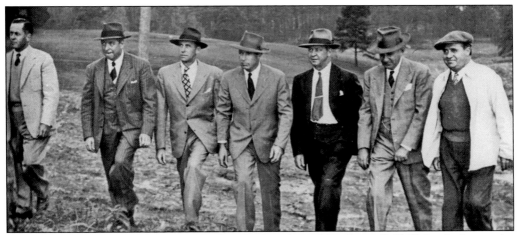

This photograph shows the men involved in the founding of Peachtree Golf Club, which uses the old Samuel House home as its clubhouse. Pictured here are, from left to right, Robert T. Jones Jr., John O. Chiles, Charlie Black, Dick Garlington, Don Irvin, Charlie Currie, and Robert Trent Jones. They are walking the property in Brookhaven that was under consideration for a new golf club. Robert T. Jones Jr. was known as "Bobby," but his friends called him "Bob." Robert Trent Jones was an excellent golfer himself and was the architect Bobby Jones selected to design the course. To avoid confusion, Robert Trent Jones offered to go by Trent Jones. (Peachtree Golf Club.)

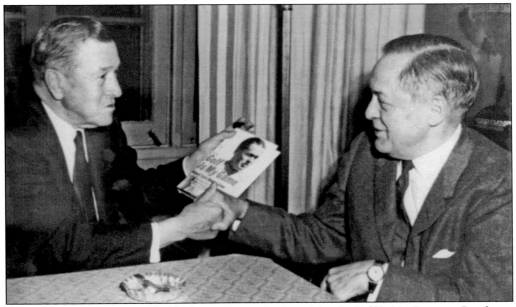

Robert Woodruff (left) and Bobby Jones discuss the latter's book, *Golf Is My Game*, at Peachtree Golf Club. The book was published in 1960. The idea for Peachtree Golf Club came from Jones becoming frustrated with long waits at East Lake Golf Club. It also happened that whenever fans found out he was going to be playing somewhere, they gathered to watch. Jones could play at Augusta National Golf Club, home to the Masters golf tournament, but it was closed from May to October. He asked Ed Dudley, head professional at Augusta National at the time, for a recommendation for a golf course architect. Dudley recommended Robert Trent Jones. (Peachtree Golf Club.)

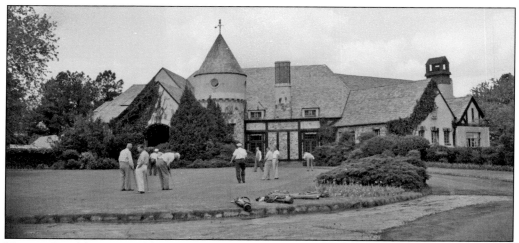

Historic Brookhaven neighborhoods were planned around the Brookhaven Country Club. The neighborhood and golf course was the first golfing community built in Georgia. The Brookhaven Country Club opened in January 1912 and was the second golf club in Atlanta, following the East Lake Country Club. Historic Brookhaven is listed in the National Register of Historic Places. The styles of homes built in the neighborhood include Colonial, Georgian Revival, and Cape Cod. Three subdivisions were part of the development: Brookhaven Estates was laid out in 1910 by investors from the Mechanical and Manufacturers Club, Country Club Estates was laid in 1929, and the last section was platted in 1936 but built in 1942 by the Carlton Operating Company. (Georgia State University Archives, Lane Brothers Collection)

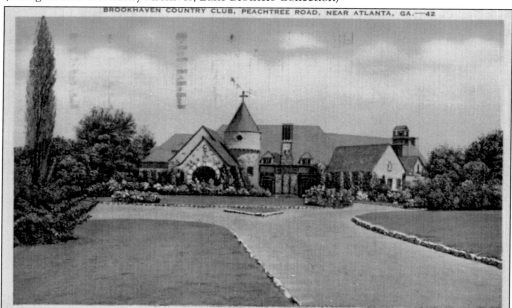

Postcards were often produced for landmarks, and this one dates to 1942. The description on the back reads, "Located thirteen miles from Atlanta is the Country Club of the Capital City Club. Eighteen acre lake used for swimming, boating, and fishing. Total area 298 acres. Eighteen hole, double grass green golf course, three double and one single tennis court." (Valerie Mathis Biggerstaff.)

This is a 1940s photograph of a home in the neighborhoods surrounding the Brookhaven Country Club. By this time, the Capital City Club had purchased the club and renamed it Capital City Country Club. (Georgia State University.)

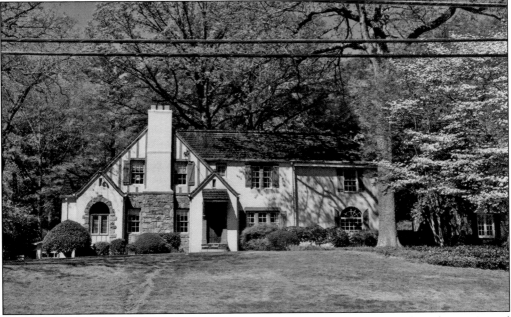

This historic Brookhaven house was home to Sally Batson Gurley as a girl in the 1930s and 1940s. The home, located at 4 Brookhaven Drive, was built in 1926 in the Tudor Revival style. Batson recalls riding her bicycle in the neighborhood as a girl. Her mother drove her to R.L. Hope Elementary School, and then her family moved so she would be able to walk to North Fulton High School. (Sally Batson Gurley.)

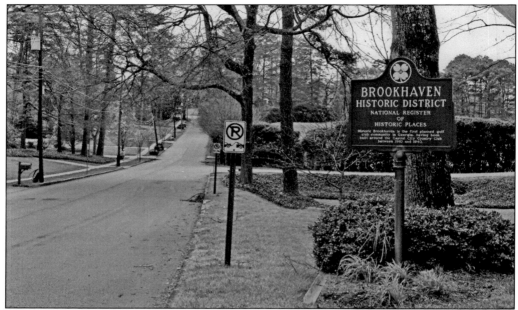

The Brookhaven Historic District is listed in the National Register of Historic Places. This marker identifies the historic neighborhood and tells that it is "the first planned golf club community in Georgia having been built around the Capital City Country Club between 1910 and 1940." The land for the neighborhoods came from the holdings of Isham Stovall and Solomon Goodwin. (Photograph by John Dickerson.)

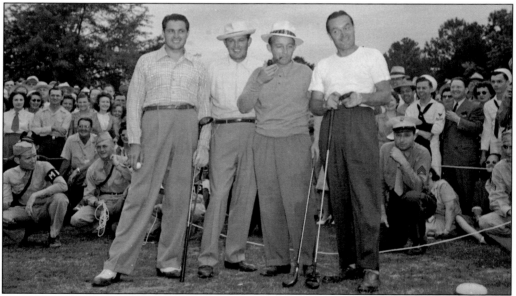

Bob Hope (far right) and Bing Crosby (second from right) are pictured here at the Capital City Country Club. Both avid golfers, they sometimes played at this club and the Peachtree Golf Club just down Peachtree Road. The golf course at Brookhaven Golf Club, which later became part of the Capital City Club, was designed by golf course architect Robert H. Parker. (Georgia State University Archives, Lane Brothers Collection.)

Z.W. Jones and his wife, Margaret, purchased this home on Standard Drive in the 1920s. The street is now known as University Drive. They came to the area, found a real estate office along Peachtree Road, and were told about a neighborhood called Brookhaven Heights. The Joneses were responsible for starting the Brookhaven School. (Corinne Jordan Dodd.)

The contrast between old and new in the Lynwood Park community is evident in this photograph. Old homes were built in the "shotgun style" in the 1920s and 1930s for an entirely African American community; while new, three-story homes built now make up about 90 percent of the gentrified 50-acre development. In the early days of this traditionally black community, many worked at the nearby golf courses and mansions of Historic Brookhaven. Rising real estate values brought about the redevelopment of the community, which includes a recreation center, swimming pool, tennis courts and ball fields. (Photograph by Valerie Mathis Biggerstaff.)

Dr. Luther Fischer built his home on 130 acres along Chamblee Dunwoody Road. The home is now in the city of Brookhaven and is part of a residential development known as Fischer Preserve. The home was designed by renowned architect Phillip Trammel Schutze, who designed many beautiful homes and buildings in Atlanta, including the Swan House, East Lake Country Club, and Glenn Memorial Church. Dr. Fischer and Dr. Edward Campbell Davis founded the Davis-Fischer Sanitarium in Atlanta, which later became Crawford Long Hospital and is now known as Emory Midtow. (Ren Davis.)

The driveway along the back of the Fischer Mansion was often lined with carriages and cars filled with people coming to see Dr. Fischer's "Flowerland." He planted elaborate gardens on the property for the enjoyment of his wife, Lucy, who had become ill. He later opened a floral shop near the Crawford Long hospital and named it "Flowerland." This photograph of the home was taken when it was occupied by Unity Church in the 1970s. (Photograph by Patricia Sabin.)

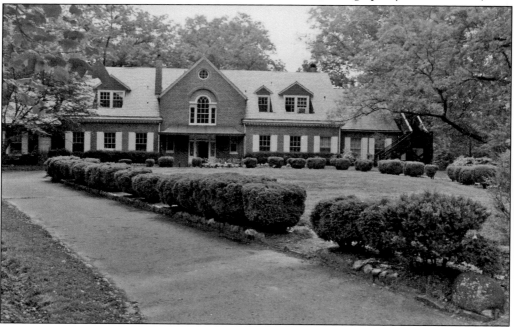

In August 1962, the Reilly family took photographs of the gardens behind the Fischer Mansion. Elaine Reilly was a student at the D'Youville Academy, which occupied the home and property at that time. The bridge across Nancy Creek no longer exists. This area behind Fischer Mansion was where Dr. Luther Fischer planted extensive gardens for his wife, Lucy, to enjoy. There was also a fountain, pond, and footbridge. In the late 1800s, this property was owned by Confederate veteran William Wallace. He operated a sawmill and furniture shop and sold furniture in Atlanta, Canton, Alpharetta, Cumming, and Gainesville. When the 1895 Cotton States and International Exposition was held at Piedmont Park, he furnished 1,000 tables for the event. (Photograph by Elaine Reilly.)

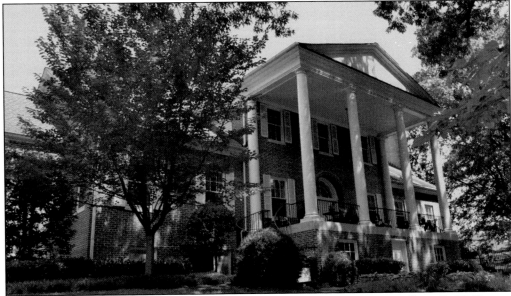

Before Dr. Luther Fischer and Fischer Mansion, this land belonged to William R. Wallace, a Confederate veteran who purchased 1,100 acres of land from Ezekial Mason in the 1880s. Wallace ran a sawmill on Nancy Creek, built furniture, and ran a furniture shop on his property. (The Preserve at Fischer Mansion.)

This house was relocated from the present-day site of Cherokee Plaza to Murphey Candler Park in 1952. It became the home for the caretaker of the park, Melvin Farrell, and his family. In later years, the home was used by a Sea Scout troop and became known as the Sea Scout Hut. It is now part of the Brookhaven Parks and Recreation Department. There are plans to renovate the old building and put it back into use. (Photograph by John Dickerson.)

The Reilly family moved into this new home on Hearst Drive in 1953; it was a typical ranch-style home of that time period. Elaine Reilly is pictured in the driveway. Many of these older homes, including the former Reilly home, are being razed to make way for larger homes. The house was located on Silver Lake, built by William Ashford and the Silver Lake Company. The lake and early homes were built as part of a summer-home community. (Tom Reilly.)

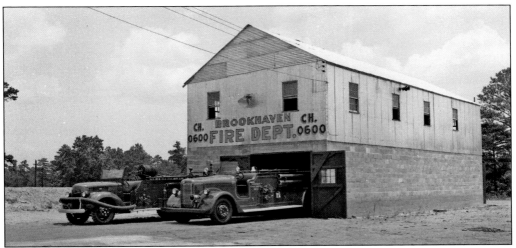

This photograph of the Brookhaven Fire Department building was taken in the 1940s. In the area of North Druid Hills and Peachtree Road were several businesses, including Brookhaven Supply Company, Bagley Electric, a laundry, Brookhaven Pharmacy, and an A&P grocery store. There was also a gas station and the fire station. The Brookhaven Picture Show was across from the drugstore and was run by John and Della Tittle. This was a thriving commercial area. CH0600 was the phone number; CH stood for Cherokee. (Georgia State University.)

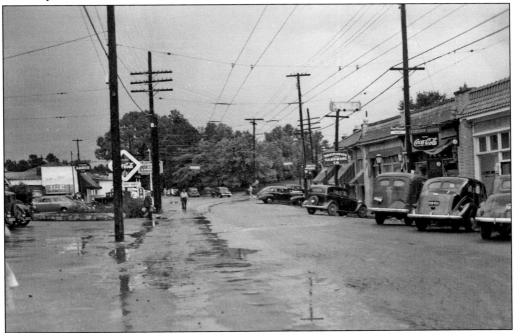

This street scene along Peachtree Road in Brookhaven shows the curve that existed at that time. When the road was straightened in 1972, these businesses were demolished. However, in the 1940s, this was a thriving area, with Brookhaven Hardware and Harkey's Drugs on the right. The post office was also located on the right in the first building visible in the photograph. Other businesses, such as the Amoco/Standard Oil gasoline station, are visible on the left side of this photograph. (Georgia State University.)

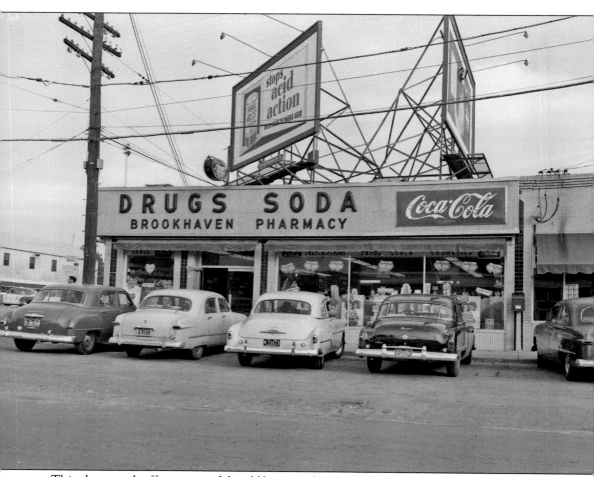

This photograph offers a view of the old business district in Brookhaven, which was on Peachtree Road from the 1940s until 1972, when it was torn down. The Brookhaven Pharmacy was a popular gathering place for the community. (Georgia State University.)

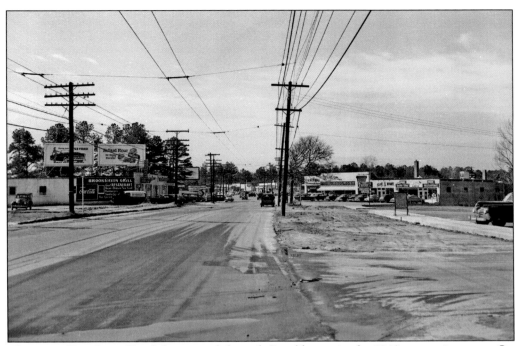

The part of Peachtree Road that passed through Brookhaven in the 1940s was quite curvy. On the right in this photograph, a Woolworth's and several other businesses are visible. In the far background at right is a Pure gasoline station. (Georgia State University.)

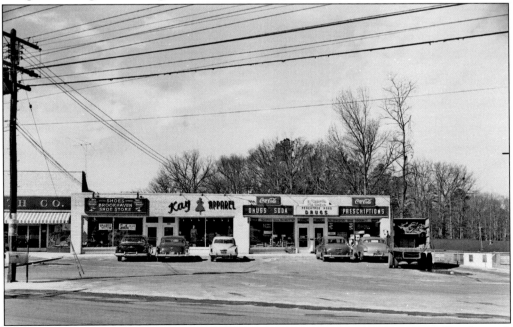

A closer view of the stores to the right of Woolworth's shows Brookhaven Shoe Store, Kay Apparel, and Peachtree Road Drug Store. Above the drugstore sign is an advertisement for Moore's Ice Cream. (Georgia State University.)

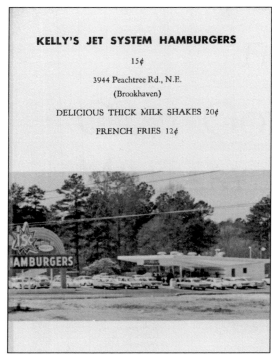

Kelly's Jet System Hamburgers was a hangout for Oglethorpe University students in the 1950s. This advertisement is found in one of the *Yamacraw* yearbooks. The establishment was located along Peachtree Road, close to the Peachtree Dunwoody intersection. (Oglethorpe University.)

Patterson's Oglethorpe Funeral Home was planned in 1960 to bring Patterson's services to families living north of Atlanta. The Spring Hill location, constructed in 1928 on Spring Street, was designed by renowned Atlanta architect Philip Trammel Shutze. Fred Patterson selected Lewis "Buck" Crook to design the Oglethorpe location. Having trained under Francis Palmer Smith at the Georgia Institute of Technology College of Architecture and apprenticed under Neil Reed, Crook was part of the architectural firm Ivey and Crook. Other famous Ivey and Crook buildings include the Candler Library and Candler home (now the Emory University president's home) at Emory University, Trinity Presbyterian Church, Druid Hills Methodist Church, and Druid Hills High School. (H.M. Patterson & Son–Oglethorpe Hill Chapel.)

54

Five

Camp Gordon and
Military Hospitals

World War I encampment Camp Gordon was built in 1917 on 2,400 acres north of Atlanta, primarily in Chamblee. A large portion of what was once Camp Gordon is now located within the DeKalb-Peachtree Airport property. This Southern Railway map of World War I's Camp Gordon shows that the camp extended into Brookhaven and down to Silver Lake, Goodwin's Crossing, and adjacent to Oglethorpe University. Goodwin's Crossing was a railroad stop on the Goodwin property. The Atlanta streetcar system was extended down to Oglethorpe, then to Nancy Creek Baptist Church, and eventually all the way to Camp Gordon. This allowed soldiers to travel from Camp Gordon to Atlanta. Some 232 Oglethorpe students joined the Army corps when Camp Gordon opened. (James Kevin Knettel.)

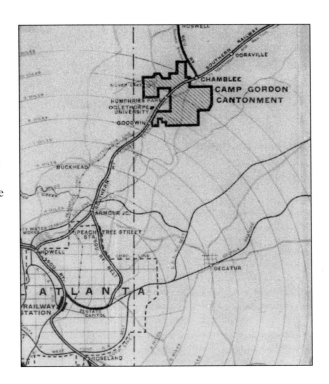

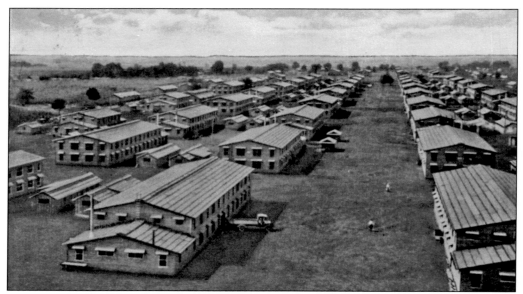

This partial view of Camp Gordon, located in Chamblee, shows several of the barracks built to accommodate 46,612 men. By July 26, 1917, more than 150 buildings had been completed, and Camp Gordon opened its gates on September 5, 1917. Men from the surrounding communities helped construct Camp Gordon. On the south end of where DeKalb-Peachtree Airport is located today, along Dresden Drive, there was a huge arched entrance to Camp Gordon. (Valerie Mathis Biggerstaff.)

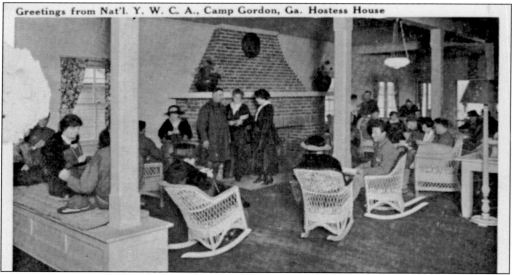

The YWCA set up a hostess house at Camp Gordon where soldiers could relax and talk with women who lived in the community. The house had a fireplace and furnishings to help the soldiers feel that this was a home away from home. The YWCA and YMCA ran activities that people might expect today from the USO. There were sporting events, singings, and a library. Another goal was to meet the spiritual needs of the soldiers. During a time of segregation and inequality in the United States, the YMCA offered services to both white and black recruits. (Valerie Mathis Biggerstaff.)

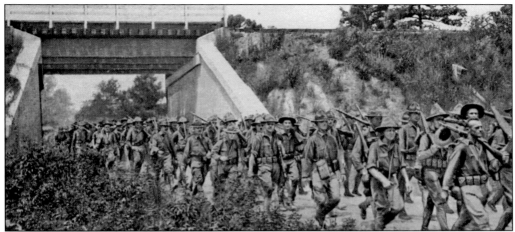

The soldiers of World War I encampment Camp Gordon went on long marches around the area, sometimes marching for up to 10 miles. The camp was located in Chamblee, Georgia; however, the marches would often take soldiers into Brookhaven. This image is believed to have been taken in front of a Southern Railway overpass at either today's Dresden Drive or North Druid Hills Road near Peachtree Road. At the time, Dresden Drive was known as Candler Road. The camp was intentionally located near the railroad so that supplies could be easily transported. (Valerie Mathis Biggerstaff.)

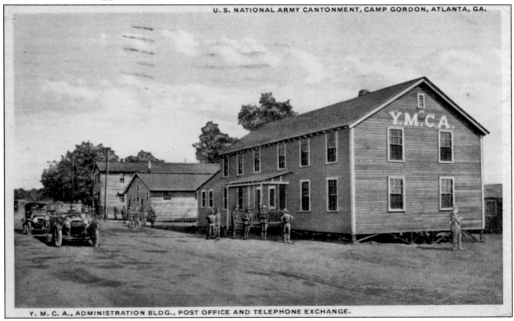

This postcard shows the YMCA, post office, and telephone exchange for soldiers stationed at Camp Gordon. The YMCA coordinated recreational services for the soldiers, including baseball games. One of the soldiers stationed at Camp Gordon was professional baseball pitcher Leon Cadore. Cadore won all of the Camp Gordon games in which he pitched. During his service, he used a 10-day furlough to play several games for the Brooklyn Dodgers. Football was also a popular activity at the camp, and opponents included teams from nearby colleges such as Georgia Tech, the University of Alabama, and Auburn University. (Valerie Mathis Biggerstaff.)

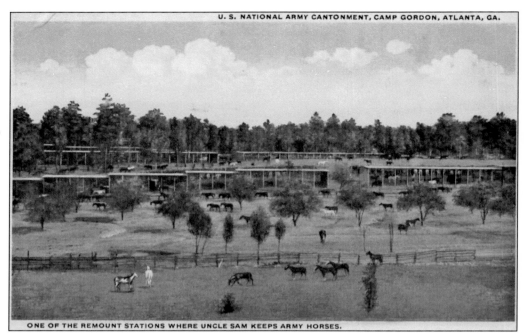

The Camp Gordon remount station is pictured on this postcard. The remount station was located at the present-day intersection of Ashford Dunwoody and Johnson Ferry Roads. It extended onto parts of what is now the Peachtree Golf Club property. (James Knettel.)

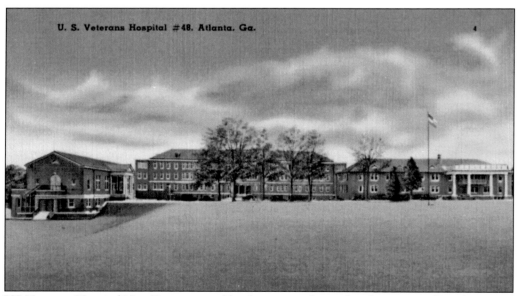

US Veterans Hospital No. 48 was a grand brick structure located at the corner of Peachtree and Osborne Roads. It was built in the 1920s to take care of veterans of World War I. On October 11, 1927, Charles Lindbergh stopped at the hospital and visited some of the patients. In 1967, the Veterans Hospital was moved to a new location on Clairmont Road, and the old hospital was demolished. Today, this is the location of the DeKalb Services Center and Brookhaven Park. (Valerie Mathis Biggerstaff.)

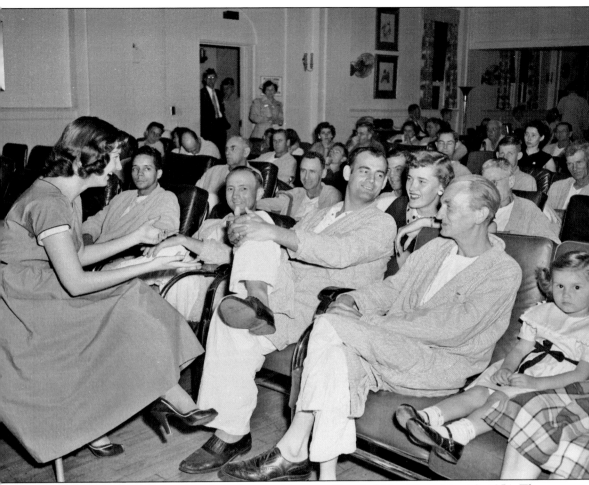

Coca-Cola employees visited with patients at Veterans Hospital No. 48 on May 12, 1954. The Veterans Hospital was first established to care for veterans of World War I, but it continued to serve veterans of World War II. (Georgia State University Archives, Lane Brothers Collection.)

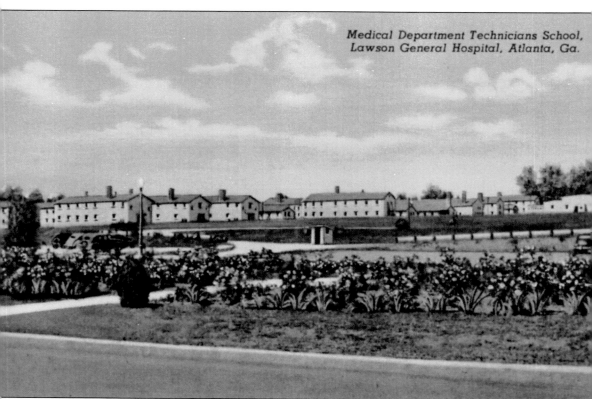

Medical Department Technicians School, Lawson General Hospital, Atlanta, Ga.

In preparation for World War II, Lawson General Hospital was built as part of Naval Air Station Atlanta, adjacent to where the IRS is located today. It was intended to serve up to 2,500 military patients. However, that number increased to 4,000. With the onset of World War II, the hospital began to specialize in prosthetics. Lawson General Hospital closed in 1946, but West Hospital Avenue in Chamblee remains as a reminder. The hospital was named for Thomas Lawson, who finished the study of medicine by age 19 before serving in the War of 1812. Although it was located in Chamblee, the hospital was important to the community of Brookhaven, and some of the facilities were used by the Our Lady of Assumption Parish around 1950. (Valerie Mathis Biggerstaff.)

Six

SCHOOLS

The Brookhaven School, which opened in 1924, was built along North Druid Hills Road just east of the railroad. The school was founded by Z.W. Jones and his wife, Margaret, who had moved to the area and found that there was no school for their two daughters. They began teaching in their own home, and soon there were more students that they could accommodate, so they began to look into building a school. This photograph shows Margaret Jones on her birthday at the school. (Corinne Jordan Dodd.)

Prior to 1900, a school had been located on Osborne Road and was called Cross Keys; however, this school was closed at the time Z.W. and Margaret Jones moved to Brookhaven. The students met first at the Joneses' home, then at another home across the road, then at one on Pine Grove

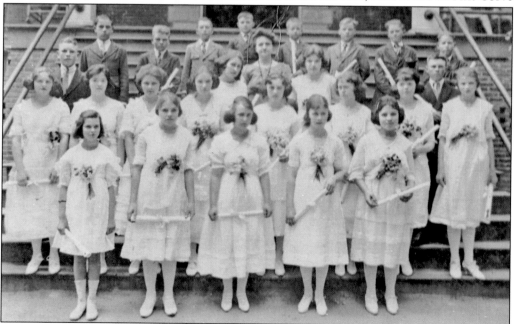

This early photograph of the students of Brookhaven School may have been taken at a local church before the school was built at North Druid Hills Road and Fernwood Drive. This was their graduation day, and each student is dressed in his or her best and holds a diploma. Margaret Jones, cofounder of the school, is standing in the center among the students. (Corinne Jordan Dodd.)

Avenue. The Joneses asked for a bond issue but were turned down until, finally, it was successful, and four lots were purchased on Fernwood Drive for the school. The brick Brookhaven School had six classrooms, an auditorium, an office, and bathrooms. (Corinne Jordan Dodd.)

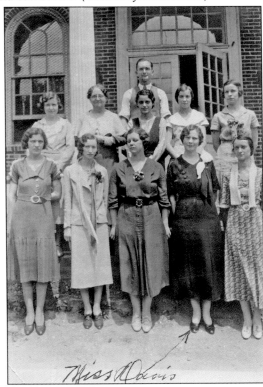

Brookhaven School taught children through eighth grade. In the 1930s, both the Brookhaven School and Brookhaven Junior High School were in the same building. The faculty and administration of Brookhaven School are shown posing on the front steps around 1933. Pictured are, from left to right, (first row) Margaret Roberts, Lucille Warren, Estelle Lindsey, assistant principal Louise Davis, and ? Lindsey; (second row) Bertha Wright, principal Margaret Jones, Katie ?, ? Warren, and Myrtle Wright; (third row) ? Ford. (Corinne Jordan Dodd.)

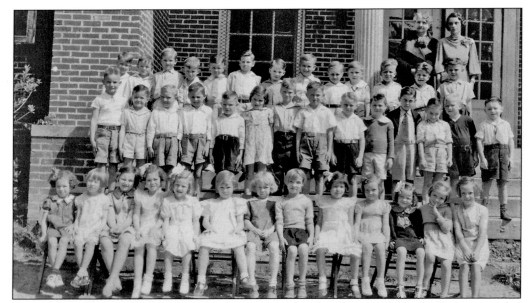

First-grade students at Brookhaven School are gathered in this photograph. Becky Vining attended Brookhaven School, and she recalls that they would hear the train passing by while in class, as the railroad was located close to the school. In later years, the school building became the Gearhart Building and housed offices for businesses and doctors. (Corinne Jordan Dodd.)

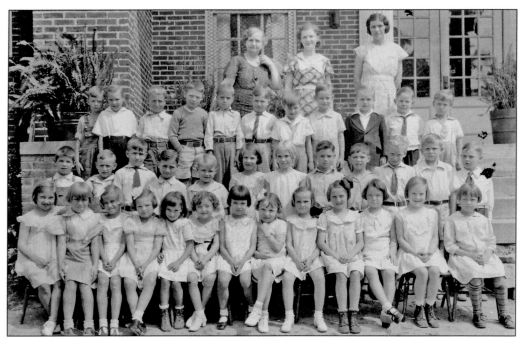

Second-grade students at the Brookhaven School pose for their annual group photograph in 1930. Standing behind the students are, from left to right, principal Margaret Jones, Miss Asken, and Miss Margaret. (Corinne Jordan Dodd.)

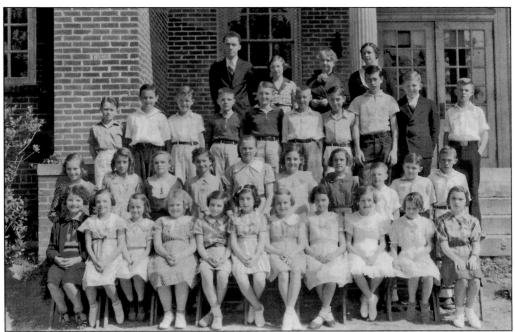

In the earliest days of Brookhaven School, Z.W. and Margaret Jones taught in their home on Standard Drive. As more parents asked the Joneses to teach their children, they moved into a four-room home on Pine Grove Avenue. The students brought chairs from home, and the teacher's desk was a crate. (Corinne Jordan Dodd.)

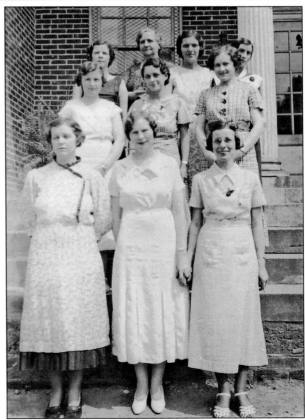

Teachers and administrative employees gathered on the steps of the Brookhaven School for this photograph. Margaret Jones is standing behind all the other employees (second from left in the third row). Louise Davis is in the center of the first row. Davis later became principal when Jones retired. The Brookhaven PTA began when school was held at a home on Pine Grove Avenue. The first president was Lena Adams Streckfuss. The PTA decided it must campaign for a real school building for the students. (Corinne Jordan Dodd.)

A graduation program for Brookhaven Junior High School shows that music, prayer, and readings were part of the festivities, as well as awarding diplomas. Having studied at Dalton Female College, Athens Normal School, and Emory University, Margaret Jones was principal of the school. (Corinne Jordan Dodd.)

COMMENCEMENT EXERCISES
BROOKHAVEN JR. HIGH SCHOOL
CLASS OF
1931
SCHOOL AUDITORIUM, MAY 28

❖══════❖

1. Class March,_____ from "Aida"

2. Invocation._____ Mr. Z. W. Jones

3. Class Song, _____ "I hear the Bees A-Humming"

4. Salutatory,_____ Estelle Harris

5. Welcome by Class President,_____ Mildred Cox

6. Class Diagnosis, _____ Elizabeth Hambrick

7, Sextet of Girls,_____ "Moonlight and Roses"

8. Class Will,_____ Elizabeth Fletcher

9. Class History,_____ Roy Palmer

10. Valedictory, _____ Gladys Lindsey

11. Class Song,_____ "The World is waiting for the Sunrise"

12. Baccalaureate Address,_____ Mrs. R. H. Hankinson

13. Delivery of Certificates,_____ Mr. D. K. Palmer

14. Benediction,_____ "Chant of Lord's Prayer"

This program for commencement exercises at Brookhaven Junior High School on May 28, 1931, shows that Z.W. Jones gave the invocation. Class president Mildred Cox gave a welcome speech, and the valedictorian was Gladys Lindsey. (Corinne Jordan Dodd.)

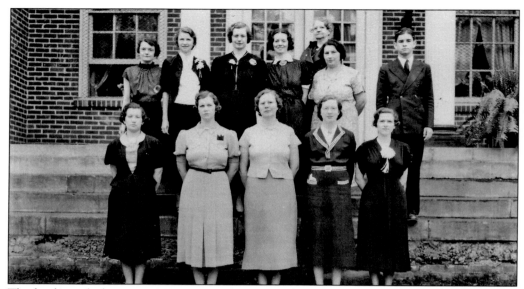

The faculty and administration grew over the years at the Brookhaven School. In this photograph, Margaret Jones is standing in the back, behind the two rows of school employees. Louise Davis is in the center of the front row. Davis was the assistant principal and, later, principal of the school. Davis was honored in 1952 by the PTA for her 25 years at Brookhaven School. Margaret Jones and Jim Cherry, then the superintendent of DeKalb County Schools, were both present and gave testimonials as to Davis's dedicated service. (Corinne Jordan Dodd.)

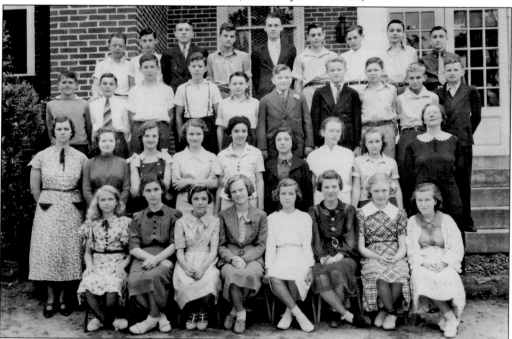

Louise Davis is at far right in the second row in this Brookhaven School photograph. The school included junior high grades for many years. Students would continue their education at Chamblee High School, the only high school in this part of DeKalb County. (Corinne Jordan Dodd.)

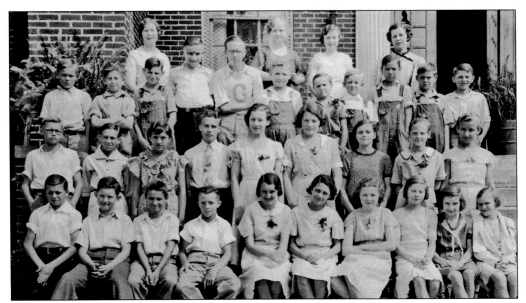

This is another Brookhaven School class picture. When Z.W. and Margaret Jones and others were attempting to get a school bond to help pay for the new building, there was much opposition in the community, as the longtime residents and older citizens did not want to pay for the cost of a school. (Corinne Jordan Dodd.)

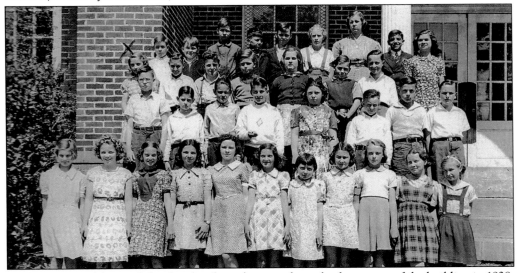

Students at Brookhaven School gather for a photograph on the front steps of the building in 1938. Becky Vining (then known as Mary Bess Tallant) contributed this photograph. Pictured here are, from left to right, (first row) Myra P., Flora J., Betty Criver, Margaret B., Clyde W., Thelma B., Betty A., Doris Brand, Edna Moore, Betty Jean Butler, and Annie Ruth Tolleson; (second row) Paul Roy Donahoo, Louis Fallaw, Johnny G., Gester Gilbert, Lucille Berber, Harry S., Jimmy B., and Thomas Puckett; (third row) Mary Bess Tallant, Charles B., Billy W., Sandy B., Jamie R., James W., John Cox, and Norma C.; (fourth row) Dean M., Gerry C., Frank T., Thomas Webb, Bobby M., Leona L., teacher Miss Lindsey, and Thomas White. These students went on to attend Chamblee High School the following year. (Becky Vining.)

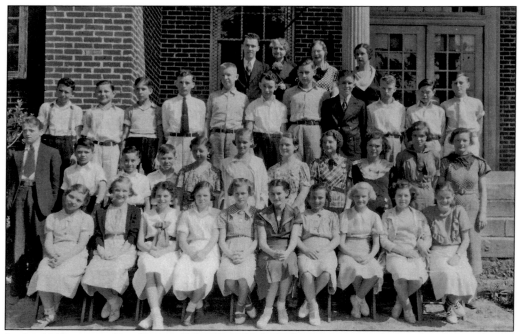

In the 1940s, a new Brookhaven School was built farther east on North Druid Hills Road. The gym of this school is still used by the Boys and Girls Club. The old school was converted to a commercial building, known as the Gearhart Building. After Brookhaven School moved, a Dr. Owens's office was among the businesses in this building. In the 1950s, Bill Lowery ran his National Recording Company there. He worked with such artists as Jerry Reed, Ray Stevens, and Sonny James. This class is pictured in front of the original building. (Corinne Jordan Dodd.)

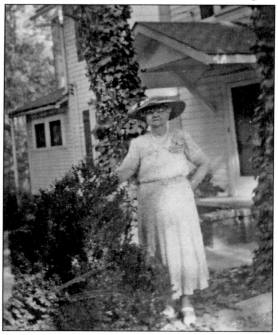

Margaret Jones cofounded the Brookhaven School in the 1920s along with her husband, Z.W. In this photograph, she is standing in front of her home, which was on a street then known as Standard Drive (now University Drive). According to Jones, only families without children could rent in the area, so with two young daughters, she and Z.W. had to build or buy a home. They searched north of Atlanta and found several lots in a neighborhood called Brookhaven Heights that had been laid out before the war. They had to help with the efforts to bring water, gas, electricity, and roads to the area. They also helped establish a post office and, most importantly, Brookhaven School. (Corinne Jordan Dodd.)

The first Lynwood School was a wooden building constructed in 1942 on land donated by J.C. Lynn and from the estate of Minnie Lee Cates, an early resident of the area. The school was built for the children who lived in the black community. DeKalb County built a new school for the African American students around 1950; that building is now used as a community center. In 1968, Lynwood closed as integration took place throughout DeKalb County. The students at Lynwood began attending Cross Keys High School, and the younger students attended local elementary schools such as Jim Cherry Elementary School. (Edgar Jones.)

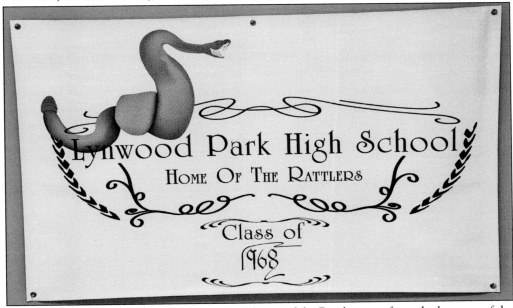

This banner from Lynwood Park High School, home of the Rattlers, was from the last year of the school's existence. After the spring of 1968, students at Lynwood were told to attend other local schools. In 2016 and 2017, a celebration of the "Lynwood Integrators" was held on Martin Luther King Jr. Day at the old Lynwood School. This banner was among the memorabilia brought to the event by former students. (Photograph by John Dickerson.)

This photograph shows the Lynwood Community Center on Osborne Road, which was previously Lynwood School. This school was built for the children of Lynwood in the 1950s. In 1954, the *Brown v. Board of Education* court ruling declared state laws establishing separate schools for blacks and whites unconstitutional. The DeKalb County School System's response to the ruling was to keep schools separate but improve schools for black students. Lynwood School was originally a nine-room building, but in 1955, the county added seven classrooms, a library, and a lunchroom. The gymnasium was added in 1962. (Photograph by Valerie Mathis Biggerstaff.)

Pictured here at the Lynwood Integrators event held on Martin Luther King Jr. Day in 2016 are, from left to right, Gary McDaniel, Brookhaven City Council member Linley Jones, Cassandra Bryant, and Johnny "Eldredge" Jackson. McDaniel, Bryant, and Jackson were students who integrated Cross Keys High School when Lynwood School was closed in 1968. McDaniel and Bryant now work at the Lynwood Community Center. (*Dunwoody Crier.*)

Former students of Lynwood School gathered in 2016 to remember the time when their neighborhood school was closed and they integrated Cross Keys High School beginning in 1968. Students brought yearbooks and shared memories of this challenging time. Lynwood School was located in a predominantly black neighborhood known as Lynwood Park and became a community center after the school was closed. (Photograph by Valerie Mathis Biggerstaff.)

These women, who were part of the Lynwood Integrators, share memories as they look at yearbooks from their school days. Some students shared their memories at the event, which included not wanting to leave the school they had attended in some cases for many years. At the time, students who were seniors asked DeKalb County School superintendent Jim Cherry to allow them to remain at Lynwood School to finish high school. He allowed them to remain, but students in all other grades were required to attend Cross Keys High School. (Photograph by John Dickerson.)

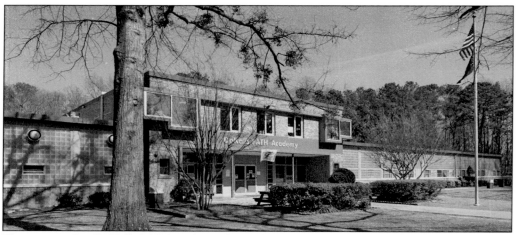

The present-day DeKalb Path Academy, located at 3007 Hermance Drive, is a charter school serving immigrant, refugee, and local children. The school, originally known as Jim Cherry School, was built in 1950 to ease overcrowding at Brookhaven School. Jim Cherry School was built on property donated by Oglethorpe University. The building was designed by Wilfred J. Gregson of Gregson and Ellis Architects. Cherry was the superintendent of DeKalb County Schools in 1950. Although he did not particularly want a school named after him, the community wanted to honor him. (Photograph by John Dickerson.)

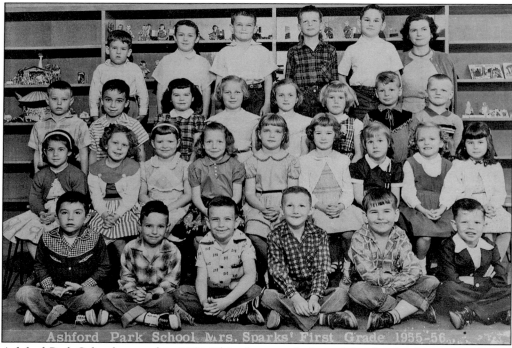

Ashford Park School opened in 1955. This photograph shows Mrs. Sparks' first grade class of 1955–1956. The school is located on Cravenridge Drive within the Ashford Park neighborhood. The name Ashford comes from W.T. Ashford, who once owned the home and land where Peachtree Golf Club is now located. Ashford also ran a nursery business known as Ashford Park Nurseries. (Ashford Park Elementary School.)

74

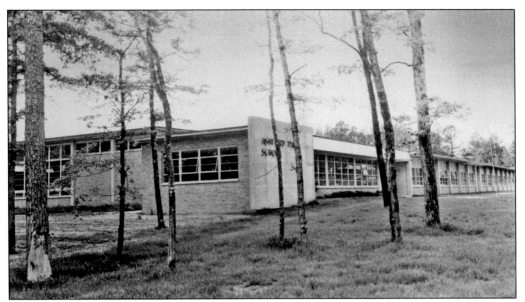

This early photograph of Ashford Park School shows the typical architecture of schools built in the mid-1950s through the 1960s, a time when the population was rapidly growing in suburban Atlanta. It was also typical at that time to build schools within an established neighborhood such as Ashford Park. (Ashford Park Elementary School.)

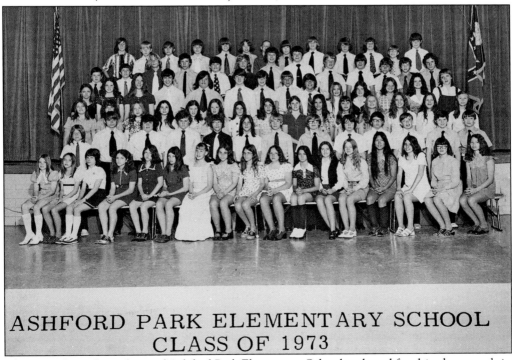

ASHFORD PARK ELEMENTARY SCHOOL
CLASS OF 1973

The seventh-grade students of Ashford Park Elementary School gathered for this photograph in 1973, their graduating year. DeKalb County did not have middle schools during this time period, so children went from seventh grade into high school. (Ashford Park Elementary School.)

When Ashford Park Elementary School opened in 1955, Dr. Leland C. Thomas served as the first principal. (Ashford Park Elementary School.)

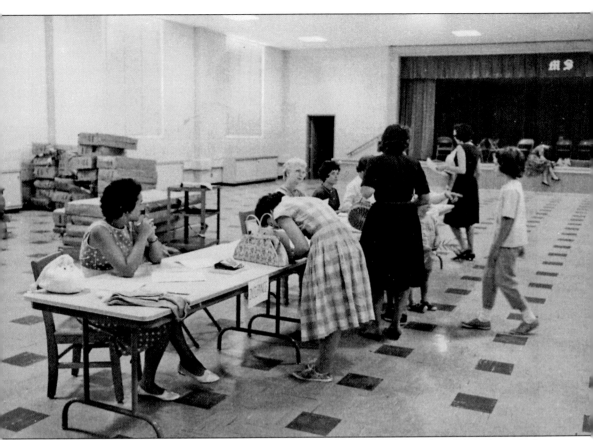

Montgomery Elementary School opened in 1964 on Ashford Dunwoody Road, and this photograph is of the school's first registration day. The school was named for James McConnell Montgomery, an early settler of DeKalb County. He was postmaster of the Standing Peachtree Post Office and ran a ferry on the Chattahoochee River near where it meets Peachtree Creek, known as Montgomery's Ferry. Montgomery also was a justice of the peace, census taker, Presbyterian church trustee, tax collector, tax receiver, Indian agent, and the first state senator for DeKalb County. (Montgomery Elementary School.)

A problem was identified early in the first year of Montgomery Elementary School—the need for a sidewalk across Nancy Creek on the same side of Ashford Dunwoody Road where the school was located. These students are using the then-new sidewalk that was constructed in December 1963 for the safety of the children. (Montgomery Elementary School.)

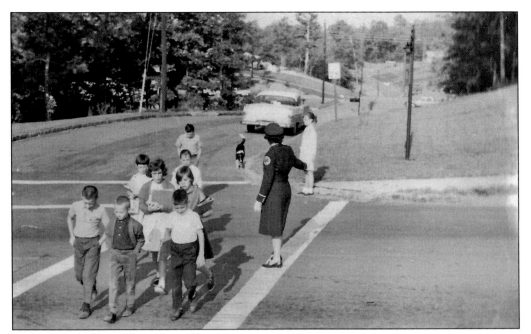

Ruth Thurmond was the police officer in charge of ensuring the children of Montgomery Elementary School could safely cross Ashford Dunwoody Road in 1965. There were also 12 safety patrol boys and girls who helped Thurmond. In March 1964, safety patrol students took the traditional trip to Washington, DC, and New York City; 1,000 DeKalb County safety patrol students made the trip that year. (Montgomery Elementary School.)

A piano was donated to Montgomery Elementary School during its opening year in 1963. The PTA had a budget of $826.50 that year, with expenses including $30 for material to build playground equipment, $300 for the library, $15 for first-aid supplies, and $75 for safety patrol raincoats. (Montgomery Elementary School.)

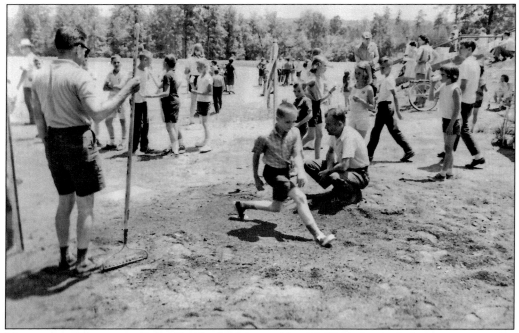

Montgomery Elementary School held a field day on May 16, 1964, that included many events for all the different grades. Events included the 100-yard dash, broad jump, high jump, softball throw, and a cross-country race. A 25¢ enrollment fee was charged to each student to help with the cost of SRA reading laboratory program materials. (Montgomery Elementary School.)

In June 1964, a dance was held for the seventh-grade students. This was part of the celebration as they graduated from Montgomery Elementary School and went on to high school. There were no middle schools in Brookhaven during this time. (Montgomery Elementary School.)

This 1964 photograph shows the first Montgomery Elementary School graduating class. Included are, in alphabetical order, Leslie Adams III, Kerry Allen, Sharon Barrington, Jerome Beatty, Barbara Bell, Valerie Bourus, Elizabeth Cassimus, Barbara Chandler, Marilynne Cheney, Deborah Clark, Irene Cox, Williams Croy Jr., George Evans, William Hughes, Jeffery Jenkins, Gerald Koeltz, James Lawwill, Donald Mason, Frances McCurley, Patricia McDaniel, Morna McEver, Larry Mesh, Stanley Miller, Janet Moon, Paula Noe, Tommy Oden, Donald Payton, Keith Porter, Glenn Rubadou, Eugene Schettgen, Virginia Scott, Shirley Smith, Cynthia Snyder, Lammie Thurmond, David Watson, Lynette Wells, Steve Williams, Edward Wolfe, and Virginia Worley. (Montgomery Elementary School.)

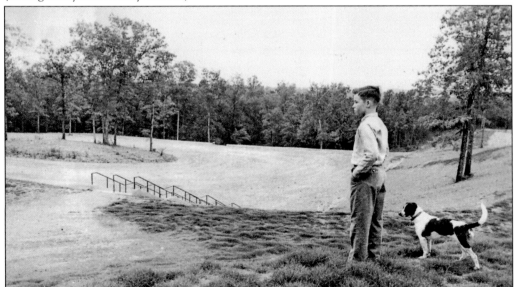

This young boy overlooking the athletic fields behind Montgomery Elementary School is unidentified. The photograph was part of the PTA scrapbook for the school's first year. According to the PTA budget, the cost of preparing the scrapbook was $25. (Montgomery Elementary School.)

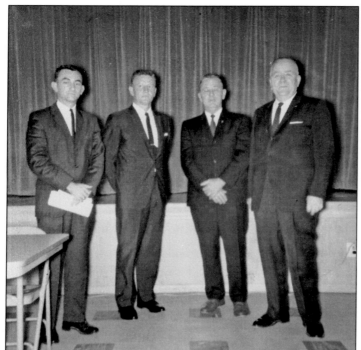

The men in this photograph taken at Montgomery Elementary School include Jim Cowart and Weldon Shows. Cowart was a builder and real estate developer in the 1960s in many north DeKalb neighborhoods. Shows was an attorney who lived in what is now Brookhaven. Shows was mayor of the village of North Atlanta and served on the DeKalb County School Board. (Montgomery Elementary School.)

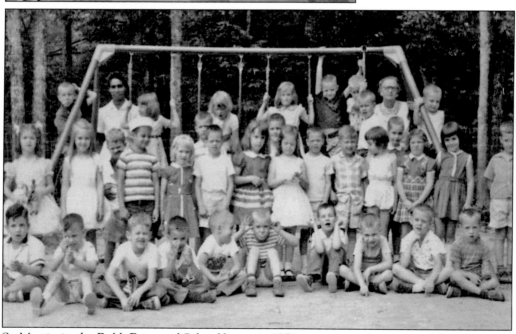

St. Martin-in-the-Fields Episcopal School began in 1959 as an outreach program of St. Martin-in-the-Fields Episcopal Church. The rector of the church at that time was Rev. Samuel Cobb, and his mother-in-law, Hazel Gailliard, thought he should start a preschool. The school began with 45 kindergarten students. This photograph shows the first kindergarten class, and the woman in the background at right is Gailliard. (St. Martin's Episcopal School.)

This photograph is of Mary Ann Nama's kindergarten class at St. Martin-in-the-Fields Episcopal School in 1981. Mary Ann Nama is among the children in the photograph, and the man pictured was the assistant priest at the time. In 1983, St. Martin's expanded by adding an elementary class and opened with 16 first-graders. This expansion was led by principal Millie Foote, who served as principal from 1978 until 1987. (St. Martin's Episcopal School.)

This was the first cross-country team at St. Martin's. Pictured at far left is coach Patti Pitoscia (now dean of students), and at far right is coach Jan Swoope, who is now retired. St. Martin's expanded by adding a middle-school program in 1992. (St. Martin's Episcopal School.)

This 1994 view of the St. Martin's Episcopal School entrance on Ashford Dunwoody Road shows how it appeared before renovations. The addition is called Warrior Hall. Today, there are around 350 students at the school, which includes classes for students starting at age three and continuing up to eighth grade. (St. Martin's Episcopal School.)

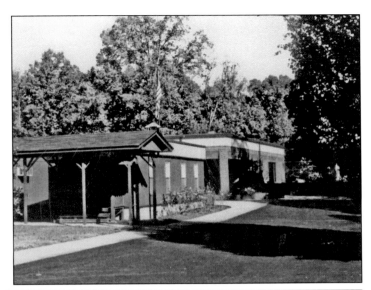

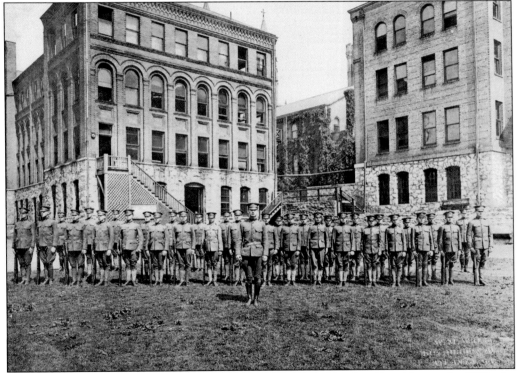

Before Marist High School moved to Ashford Dunwoody Road in Brookhaven in 1962, the school was located in downtown Atlanta and known as Marist College. The school was started in 1901 by Fr. John E. Gunn to provide a Catholic education to young men. This photograph was donated to Marist by John M. Higgins, class of 1923. He described the photograph of Company A: "As I recall, the picture was made in the scholastic year of 1918–1919. The enrollment was approximately 160. The military battalion consisted of Company A and B and the Headquarters company which included the band." (Marist School.)

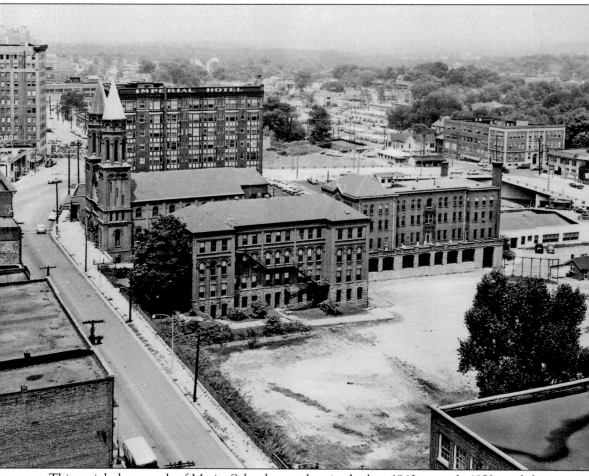

This aerial photograph of Marist School was taken in the late 1940s to early 1950s and shows the original location on Ivy Street in downtown Atlanta. The school was founded in 1901 and was first known as Marist College. It was located next to Sacred Heart Church but was relocated in the 1960s due to highway construction in downtown Atlanta. Ivy Street is now known as Peachtree Center Avenue. (Marist School.)

The students dressed in uniform and their dates donned white dresses and hats for the annual Military Prom. This photograph is from the early years of Marist School in its downtown Atlanta location. The school was originally a Catholic military day school for boys. In 1976, the school became coeducational. Today, it is a private Catholic school for students in grades seven through twelve. (Marist School.)

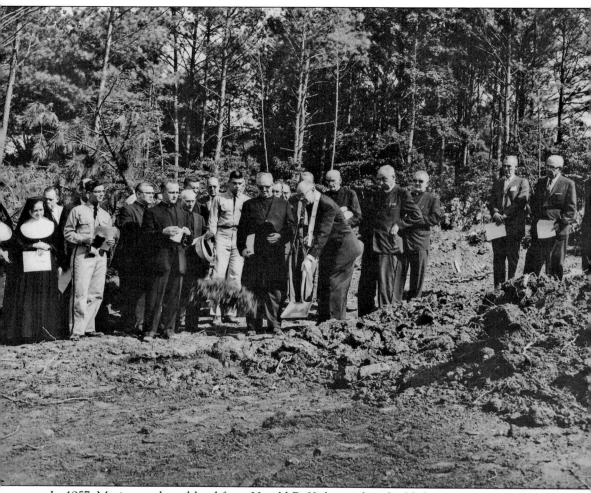

In 1957, Marist purchased land from Harold B. Kirkpatrick to build the new campus of Marist College, which would become Marist School. This photograph shows the ground-breaking ceremony for the new campus. The first school year at the campus began in 1962. (Marist School.)

This photograph shows early construction of Marist School on Ashford Dunwoody Road. The view looks out towards Ashford Dunwoody Road and Nancy Creek and shows that the area was undeveloped at that time. (Marist School.)

Marist School was designed by the architecture firm FABRAP (Finch, Alexander, Barnes, Rothschild and Paschal). This renowned group of architects included students from Georgia Tech and Massachusetts Institute of Technology and was best known for being part of the group that designed the Atlanta–Fulton County Stadium built in 1965. It also designed the Callaway Student Athletic Complex at Georgia Tech, the Coca-Cola headquarters, and the Richard B. Russell Building in downtown Atlanta. (Marist School.)

Marist School is no longer a military school; however, in 1962, when these photographs were taken, it still was. These young men in uniform are being led by the school color guard. Across the road is the former location of Hart's Mill, built along Nancy Creek, which also traverses the school property. (Marist School.)

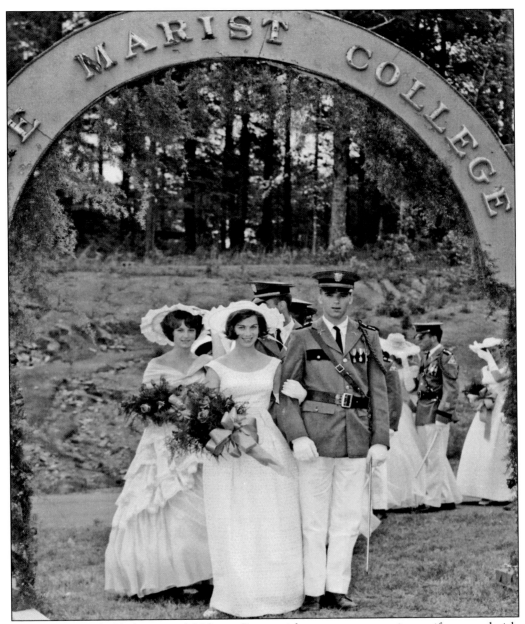

In 1964, Marist held the annual Military Prom, with young men wearing uniforms and girls in white dresses and hats. In this photograph, the attendees are walking under the old Marist College sign that was removed from the Ivy Street campus. At this time, the surrounding area along Ashford Dunwoody Road was largely undeveloped. (Marist School.)

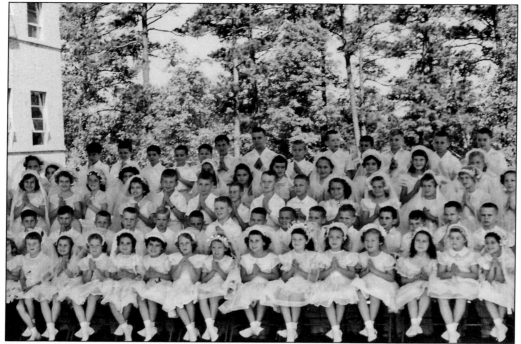

Elaine Reilly, age 12, is third from the right in the third row in this photograph and was part of the communion class of 1955 at Our Lady of the Assumption School. The white dresses and headpieces were part of the traditional ceremony. Our Lady of the Assumption School opened with 176 students in kindergarten through fifth grade. In 1957, sixth through eighth grades were added. (Tom Reilly.)

Our Lady of the Assumption School opened in 1952. The Sisters of Mercy from Savannah, Georgia, came to Atlanta to meet the educational and spiritual needs of the students. The Sisters of Mercy were instrumental in the founding of St. Joseph's Hospital in 1880. This photograph shows the original Our Lady of the Assumption School building under construction. (Tom Reilly.)

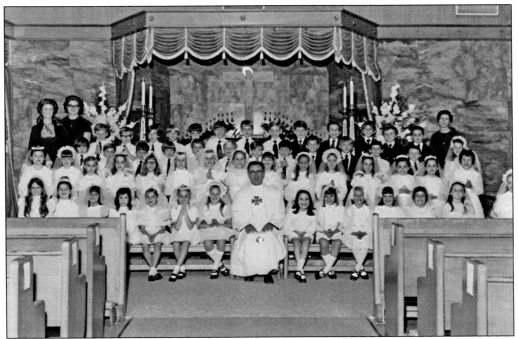

When Our Lady of the Assumption School (OLA) first opened, there were 176 students enrolled. Within five years, enrollment had increased to 652 students. Sister Mary Assumpta, RSM, was the first superior of the order at OLA. Sister Mary Christine, RSM, was the first principal. This photograph was taken in 1970 on the occasion of First Communion. (Our Lady of the Assumption School.)

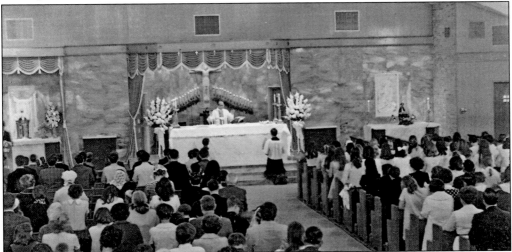

This photograph was taken at the 1970 eighth-grade graduation at Our Lady of the Assumption School, being led by Father Burkort. In 1985, a parish activities center was added, which included a gymnasium and additional classrooms. A new building was dedicated in 1998 and named Mercy Hall in honor of the Sisters of Mercy. It included a library/media center, labs, classrooms, offices, and the Chanel Center, named for Marist priest St. Peter Chanel. (Our Lady of the Assumption School.)

This August 1962 photograph of D'Youville Academy shows an outdoor Mass on the front steps and lawn of the former Fischer Mansion. The name D'Youville came from the founder of the Sisters of Charity (or Grey Nuns of Montreal), Marie-Marguerite d'Youville. When Lucy Hurt Fischer died in 1937, her husband, Luther Fischer, sold the home and land to a Mrs. Lee, who then sold it to the Atlanta Diocese of the Catholic Church. (Tom Reilly.)

Students of D'Youville Academy participate in a ceremony to honor Mary. The lawn of the old Fischer Mansion provided the perfect spot for the occasion. A large portion of the gardens of Dr. Luther Fischer, known as Flowerland, still existed on the property at that time. Nancy Creek runs directly through the property. Today, the D'Youville Condominiums, located adjacent to Fischer Mansion, are a reminder of the days of D'Youville Academy. (Tom Reilly.)

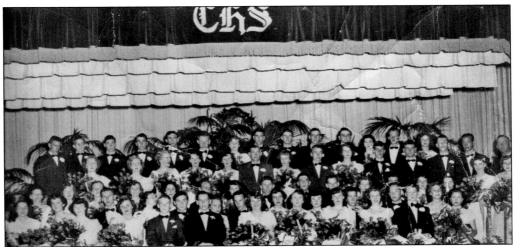

Chamblee High School was the only high school for the communities of Chamblee, Brookhaven, and Dunwoody until DeKalb County began a program to build new high schools. This photograph of the 1950 graduating class of Chamblee High School includes students from all three areas. In the late 1950s and 1960s, DeKalb expanded its high school programs. Cross Keys High School opened in 1958. (Carlton Renfroe.)

James F. Goolsby was the first principal of Cross Keys High School. Goolsby served in the Army Air Forces during World War II as a B-17 pilot. Following his time at Cross Keys High School, he went on to serve as principal and headmaster at several other schools, then served 10 years as superintendent of Valdosta City Schools. (Cross Keys High School.)

Cross Keys High School opened on North Druid Hills Road in 1958 with 28 teachers and 765 students. This photograph of Cross Keys High School is from 1960. The school is named for the crossroads that once was the center of activity for this area at Ashford Dunwoody and Johnson Ferry Roads. Ashford Dunwoody Road was once known as Cross Keys Road. The first school in the community was named Cross Keys and was located on Osborne Road around 1896. (Cross Keys High School.)

These senior class officers of Cross Keys High School were part of the first graduating class in 1961. Pictured are, from left to right, treasurer Benny Mann, president Louise Smith (behind the wheel), vice president Sally Walters, sponsor Preston Bentley, secretary Penny McCulloch, and sponsor Linda Lowe. (Cross Keys High School.)

The Cross Keys High School varsity cheerleaders posed for this photograph in 1960. The captain was Sally Walters, and the cocaptain was Jean Hefner. (Cross Keys High School.)

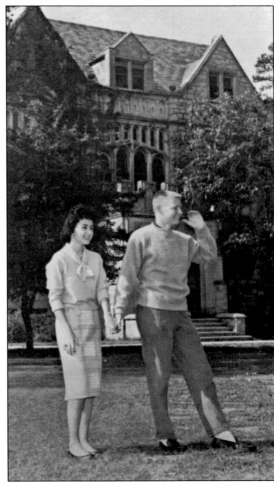

Jane Ann Barton and Paul Bennett, winners of the senior superlatives for "Most School Spirit" at Cross Keys High School, strike a pose on the nearby Oglethorpe University campus in 1962. (Cross Keys High School.)

The 1967–1968 school year was important at Cross Keys High School because it was the year that DeKalb County closed its all-black schools. This meant that students at Lynwood School had to attend Cross Keys High School. This photograph of the 1968 track team includes students who attended Lynwood the previous year. Pictured are, from left to right, (first row) Frankie Jailett, Ronnie Geller, Phil Tucker, Jimmy Langston, Raymond Jackson, PeeWee Jackson, and Louis Brown; (second row) Gary McDaniel, Steve Shankweiler, Mike Hall, Rusty Rilling, Bobby McLeer, Bobby Venable, Mike Woody, Carl Bronn, and coach James Casteel. (Cross Keys High School.)

The 1968 football team at Cross Keys High School includes, from left to right, Jack Norman, Steve Grubbs, PeeWee Jackson, Bobby Venable, Reed Hoerner, Russell Gilliland, and Randy Gay. (Cross Keys High School.)

Seven

CHURCHES

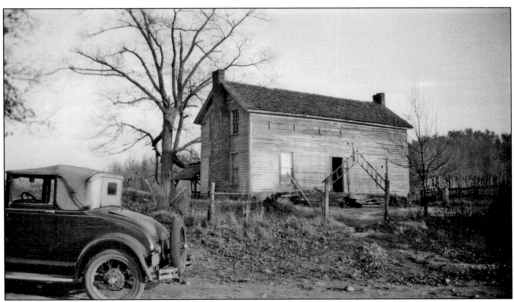

Nancy Creek Primitive Baptist Church was founded on July 3, 1824. There were 18 founding members, and one of them, William Johnston, served as a moderator in the absence of a minister. The land for the church and cemetery (located across the road) was donated by John Yancey Flowers. William Johnston's wife, Naomi, died in 1844 and was one of the first people buried in the cemetery. Although the church is within the city limits of Chamblee, it was central to the lives of many people in Cross Keys (now Brookhaven). (Atlanta History Center.)

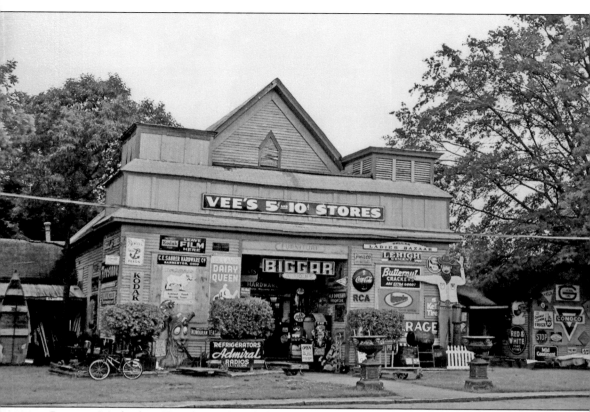

Prospect Methodist Church was founded in Chamblee in 1827, and this is another church that pioneers of Brookhaven attended. Samuel House is said to be buried in an unmarked grave in the Prospect Cemetery behind the church. The church building shown in this photograph was erected in 1885 and has most recently been home to an antiques store. An 1851 deed for the land the church was built on shows that John Yancey Flowers, acting as executor of the John W. Reeve estate, signed over two and one-half acres to Prospect trustees Samuel House, Stephen Tilly, Alfred J.H. Pools, and Jabez Loyd. This was land lot 309 of the 18th district. (Photograph by Valerie Mathis Biggerstaff.)

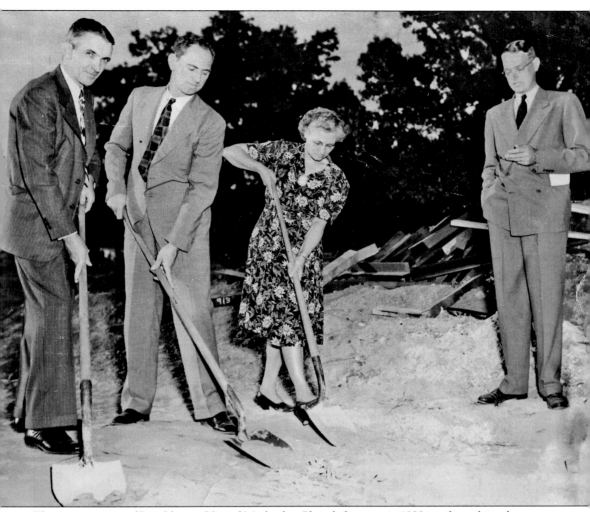

The congregation of Brookhaven United Methodist Church first met in 1922 in a log cabin adjacent to where the church sits today. They then met in the home of John Bass, at the corner of Peachtree and Decatur Roads. A problem with the ownership of the land caused the church to move, and a building was finished at the intersection of University (now Standard Drive), Thornwell, and Colonial Drives. (This structure, later used by the Brookhaven Christian Church, is pictured on page 103.) In 1945, Brookhaven Methodist Church purchased land at the corner of Briarwood and North Druid Hills Roads, where members had first met. The ground-breaking ceremony, pictured here, took place on August 4, 1947. (Brookhaven United Methodist Church.)

Come Celebrate

the 88th Homecoming of
Brookhaven United Methodist Church
and the newly renovated sanctuary
for physical accessibility.
Sunday October 9, 2011

On October 9, 2011, Brookhaven United Methodist Church celebrated its 88th anniversary and new renovations, which included increased accessibility. This is the church program from that day. (Brookhaven United Methodist Church.)

The first service was held in the new Brookhaven United Methodist Church sanctuary on April 18, 1948. This photograph is from 1968, when a new steeple was added to the church. (Brookhaven United Methodist Church.)

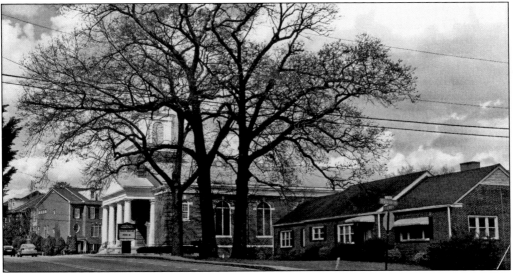

Brookhaven Baptist Church began meeting at W.J. Wehunt Grocery Store in 1922. Rev. W.F. Burdett and Rev. George P. Donaldson helped organized the church. The first pastor was Mark Williams, and the first church building was constructed in 1923. The next church building was erected in June 1938 under the leadership of Pastor John E. Cobb. Rev. Don Presley has been the pastor at Brookhaven Baptist Church since 2006. (Photograph by Valerie Mathis Biggerstaff.)

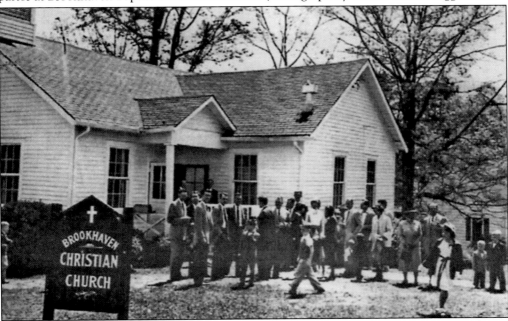

On Mother's Day in 1948, Brookhaven Christian Church began holding services at 202 Colonial Drive, the former home of Brookhaven United Methodist Church. The Methodists had just moved into their new sanctuary on North Druid Hills Road. Rev. A. Goff Bedford was the first full-time minister. Under the second minister, Rev. Harold Phillips, the church sold this property, met at Oglethorpe University for a time, and purchased a lot on Peachtree Road to build a new sanctuary. (Brookhaven Christian Church.)

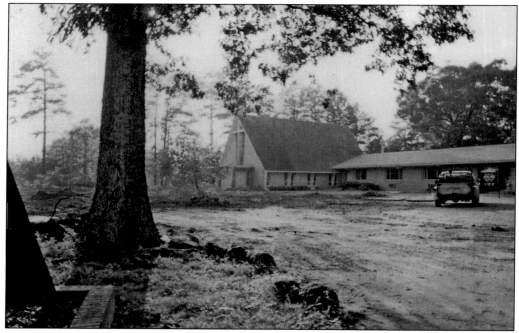

The ground-breaking ceremony for the new Brookhaven Christian Church was held on Sunday, October 5, 1958. The church was finished in May 1959, and the first services were held on May 31. The church had 252 members at that time. (Brookhaven Christian Church.)

From November 1951 until July 1952, Brookhaven Christian Church did not have a minister. The church work was done by layman H.C. Garrard. Then, Rev. Harold E. Phillips arrived along with his wife, Madeline. Reverend Phillips helped the church sell its old church home, move into a larger space at Oglethorpe University, and purchase the lot where a new church was built. The Brookhaven Christian Church shown in this photograph was completed in May 1959. (Brookhaven Christian Church.)

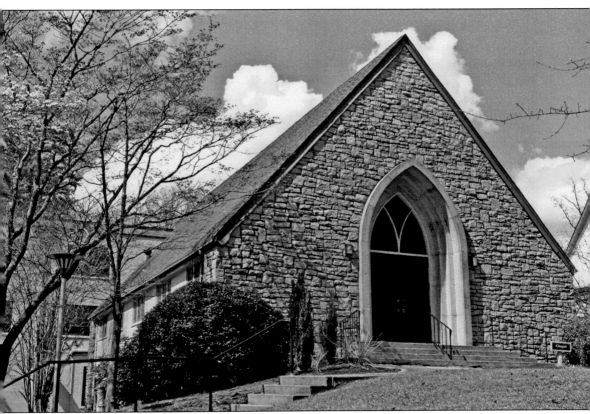

Oglethorpe Presbyterian Church was built on land donated by Oglethorpe University on Lanier Drive. Dr. Philip Weltner, president of Oglethorpe University, and his wife wanted a Presbyterian church to be established in the area. The church was organized in March 1949 with 43 charter members. The first pastor was Rev. F.M. Legerton. Attending the ground-breaking ceremony were Dr. Eugene T. Wilson, pastor of the Peachtree Road Presbyterian Church, and Dr. Weltner. This photograph is of the chapel. (Photograph by Valerie Mathis Biggerstaff.)

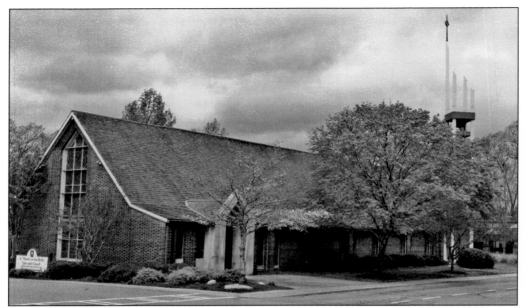

The name St. Martin-in-the-Fields was given to this Brookhaven church because of its significance to James Edward Oglethorpe, founder of the Georgia colony and namesake of Oglethorpe University. Oglethorpe was baptized at St. Martin-in-the-Fields church in London on December 23, 1696. Rev. A.L. Burgreen came from Florida in 1952 to be the first permanent rector at St. Martin-in-the-Fields. (Photograph by Valerie Mathis Biggerstaff.)

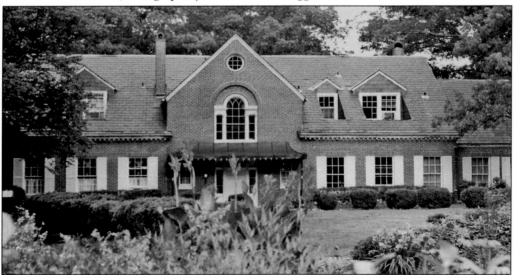

From 1977 until 1985, Unity Church met at the old mansion of Dr. Luther Fischer and his wife, Lucy. Patricia Sabin recorded some of the details that remained of the old home at that time, such as carved mantels, Art Deco bathrooms, and hardwood plank and tile floors. Unity Church moved when a new church was built. The Fischer home was designed by famous architect Philip Shutze and is listed in the National Register of Historic Places. The home, which became a school and then a church, is now the centerpiece of a development known as the Preserve at Fischer Mansion. (Patricia Sabin.)

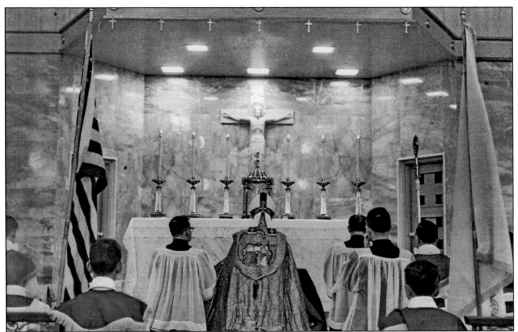

Land for Our Lady of the Assumption Parish and School was purchased from Oglethorpe University and included eight acres along Hearst Drive. The first parishioners of the church met in the converted Army barracks of Naval Air Station Atlanta and later at Lawson General Hospital and Jim Cherry School with the guidance of Msgr. Joseph E. Moylan. In May 1952, the school chapel was completed and began to be used by the parish. (Our Lady of the Assumption Church.)

The name of Our Lady of the Assumption Church was recommended by Archbishop Gerald P. O'Hara of the Savannah-Atlanta Diocese. He wrote, "We would be honoring Our Lady through the newly declared dogma of her Assumption." This photograph of the church was taken in 1970. (Our Lady of the Assumption Church.)

The current church of Our Lady of the Assumption is the result of plans in 1999, when the Parish Pastoral Council authorized a building committee to assess the future needs of the parish. Later that year, the committee presented the parish with a plan for a permanent church and a new parish hall building. The Archdiocese of Atlanta gave the plans its blessing, fundraising began, and in 2003, construction began. (Our Lady of the Assumption Church.)

The construction of the new church included two buildings. The church building would include a daily chapel, choir rehearsal room, bride's room, and a meeting room. Preschool classrooms, a parish hall, a youth room, and a maintenance room would be included in the second building. The new church and facilities were consecrated on November 4, 2005, by Archbishop Wilton D. Gregory, DD. (Our Lady of the Assumption Church.)

Little Zion Church dates back to 1923, when families first began to buy lots and build homes in the Lynwood community. The church is located at the intersection of Mae Avenue and Cates Avenue, now surrounded by a mixture of older one-story homes and new multilevel homes, as the area has experienced much gentrification. Barbara Shaw recalls first coming to this church around 1955 and hearing singing as she approached the doors. The church has an active congregation that serves the community, with members who have moved away returning for special occasions. (Photograph by John Dickerson.)

China Grove Missionary First Baptist Church is located on Osborne Road within the Lynwood community. China Grove began in 1921, when some people decided to organize for prayer. They began meeting at a house that was located on a rock and named the place Hard Rock. The church moved to a location on Mae Avenue under the leadership of Rev. O.C. Woods. It was during this time that the church became known as China Grove Church. In 1969, a building permit was obtained, and a new church was built. (Photograph by John Dickerson.)

Lynwood Park Church was first organized in 1959. The first church building was completed on Windsor Parkway in 1962, but it was torn down in 1976. The existing church building was completed in 1977. Bishop Frankie L. Roberts is the pastor of Lynwood Park; he is assisted by his wife, Evangelist Inez Roberts. (Photograph by John Dickerson.)

St. Peters True Holiness Church, led by Pastor Sawyer, met in this building on Windsor Parkway but recently relocated. This small brick building was once a nightclub. (Photograph by John Dickerson.)

Eight

PARKS

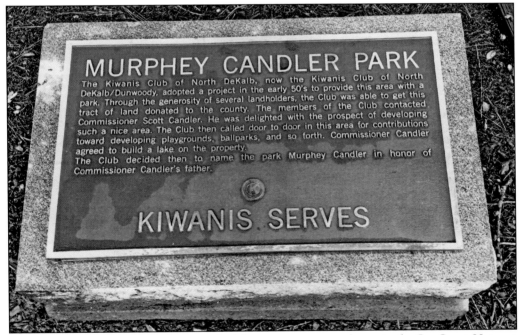

This marker was placed near the caretaker's house—or, as some know it, the Sea Scout Hut—at Murphey Candler Park. It tells the story of how the park was developed in the 1950s. The land was donated by the Fred Wilson and M.A. Long families. DeKalb County commissioner Scott Candler was contacted by the Kiwanis Club for help with establishing a park. Members of the Kiwanis Club went door-to-door in the community to ask for donations to build playgrounds and ball fields. Commissioner Candler agreed to build a lake, which is known as Candler Lake, on the property. The park is named for his father, Charles Murphey Candler. A ground-breaking ceremony was held on January 31, 1954. (Photograph by Valerie Mathis Biggerstaff.)

This old house was the home of the Farrell family during the early days, when Melvin Farrell was caretaker of the park. In the 1950s, the home was moved from its original location on Peachtree Road (in the area where Cherokee Plaza is now). It was built sometime between the 1920s and 1930s and features nine-foot ceilings, hardwood floors, original glass doorknobs, panel doors, and basketweave-tile floors. A Sea Scout troop used the home for its meetings after Farrell retired from his job as caretaker. (Photograph by John Dickerson.)

The Farrell children—Bud (left), Gail (center), and Sharon—are shown here on the front steps of the caretaker's home around 1966. Running Murphey Candler Park was a family affair, with the children's mother, Betty Jo, managing the concession stand at the baseball fields and the children working at the swimming pool. Their father, caretaker Melvin Farrell, laid out the baseball fields when the park first opened. (Farrell family.)

This photograph features Melvin and Betty Jo Farrell. Melvin became the first caretaker of Murphey Candler Park and lived in the caretaker's home with his family from the 1960s to the 1980s as he helped design the area parks. Known as "Buddy," Melvin served during World War II. Pfc. Melvin B. Farrell Sr., 29th Division, 121st Combat Engineers, Company B, participated in the D-day landing and was a prisoner of war in Sokolov (Faulkenau), Czechoslovakia. (Farrell family.)

Candler Lake, part of Murphey Candler Park, was built by Scott Candler as a lovely addition to the park. A trail circles the park, and an annual race known as the Duck Duck Goose Race is held each October. The money raised goes to the Murphey Candler Park Conservancy. Murphey Candler Park includes a swimming pool, a lake, trails, picnic areas, multiuse fields, playgrounds, and tennis courts. Many football, softball, and baseball teams play on the fields of Murphey Candler Park. (Photograph by John Dickerson.)

A ground-breaking ceremony for Murphey Candler Park was held on January 31, 1954. The roads now used to enter the park did not exist at that time, and the ceremony was held along Ashford Dunwoody Road where the future roads would be built. This photograph shows Candler Lake, which is located within the park. (Photograph by John Dickerson.)

Sharon Farrell and her brother Buddy go for a wagon ride on the property of the caretaker's cottage at Murphey Candler Park. Their father, Melvin, was the caretaker at the park. Candler Lake is visible in the background of this photograph. (Farrell family.)

Brookhaven Little League baseball began in 1958. The 1960 Brookhaven Little League team shown here was sponsored by Patterson Funeral Home and includes well-known WSB-TV reporter Richard Belcher (third from left in the second row). Belcher's father was one of the coaches (second from right in the third row). The baseball program later became known as the Murphey Candler Little League, named for the park where it was located. (Richard Belcher.)

Sharon Farrell, who lived in the Murphey Candler Park caretaker's cottage with her family, participated in cheerleading at the park in 1970. She is shown here in her uniform to cheer for the Saints. She only had to walk across the road to reach the ball fields from the caretaker's house. (Farrell family.)

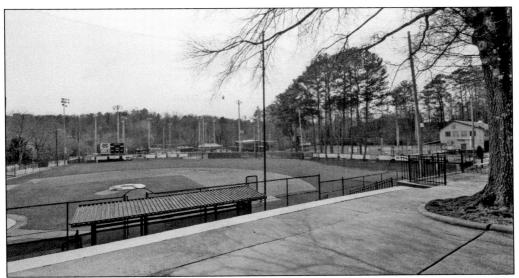

Baseball began at Murphey Candler Park in 1958 and was originally called the Brookhaven Little League. The Brookhaven Little League began with four major teams and six minor teams. Murphey Candler Park opened with one baseball field but had three by 1969. On occasion, nearby Keswick Park was used for games. In the 1960s, an opening day parade began at Cherokee Plaza, went north on Peachtree Road, and ended at Murphey Candler Park. There was a parade queen and court, followed by games and a barbecue. (Photograph by John Dickerson.)

Neighborhoods began to spring up around Murphey Candler Park soon after it was built. Homes in Nancy Creek Heights were begun in the 1950s, and homes in the Murphey Candler neighborhood were begun in the 1960s. The Murphey Candler homes section was developed by Jim Cowart, who developed many of the neighborhoods in north DeKalb County. The view in this photograph looks across the lake as people participating in the Duck Duck Goose 5K fundraiser cross the park's bridge. (Photograph by Rebecca Chase Williams.)

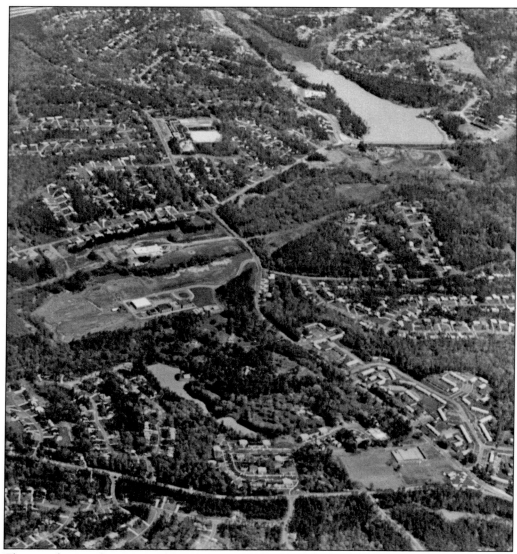

This aerial view of a portion of Brookhaven in 1969 shows some of the landmarks along Ashford Dunwoody Road. Interstate 285, which encircles Atlanta, was completed this same year. In the top right of the photograph is Murphey Candler Park, which was much smaller than it is today. The baseball fields and Candler Lake are visible. In the center of the image and on the left side of Ashford Dunwoody Road is the new campus of Marist School, relocated from downtown Atlanta in 1964. Farther along Ashford Dunwoody on the right side of the photograph are the Oglethorpe Apartments, located where Blackburn Park is now. Going back even farther in time, this was the location of military housing. (Jim Cowart.)

The 49-acre Blackburn Park, formerly part of Camp Gordon that contained officer housing, is now the site of the annual Brookhaven Cherry Blossom Festival. People planted 240 Yoshino cherry trees in the park as a way to celebrate Brookhaven in bloom. (Photograph by Rebecca Chase Williams.)

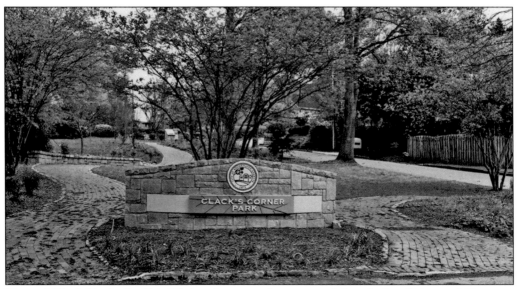

Howard Clack lived all of his life in a home at the corner of Appalachee Drive and Cartecay Drive in the Brookhaven Fields neighborhood. When he passed away, his family donated the land for a small park within the neighborhood. The park is named Clack's Corners in his memory. (Photograph by Valerie Mathis Biggerstaff)

The home that Howard Clack lived in had to be demolished, but the land became a small park within the neighborhood. Clack had lived in the home since his birth in the 1920s. The neighbors of Brookhaven Fields joined together to spearhead this project, and Clack's Corners is the result. (Photograph by Valerie Mathis Biggerstaff.)

The Brookhaven MARTA Station, located on Peachtree Road, is an important part of the city, allowing easy and inexpensive transportation for all members of the community. MARTA rail service in Atlanta began in 1979, with the Brookhaven line and station opening in 1984. An extensive archaeological study was performed by MARTA before the line and station were built in Brookhaven to ensure that construction would not disturb any significant historic sites. Some graves within Nancy Creek Primitive Baptist Church Cemetery had to be moved to make way for the tracks. (Photograph by John Dickerson.)

Nine

BROOKHAVEN BECOMES A CITY

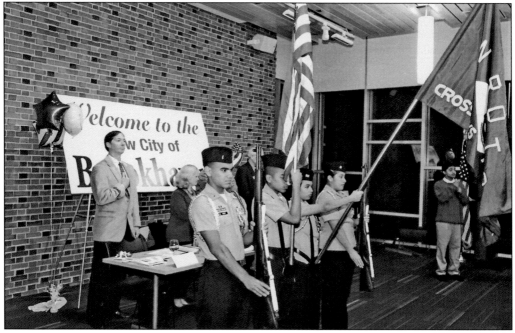

On December 16, 2012, the Cross Keys High School Color Guard kicked off the historic first meeting of the new Brookhaven City Council, held at St. Martin's Episcopal School. Brookhaven becoming a city was approved by referendum on July 31, 2012. It was the start of creating a city from scratch—adopting ordinances, finding a city hall, and hiring staff. In less than a month, Brookhaven city government opened for business for the municipality's 50,000 residents. (Photograph by John Dickerson.)

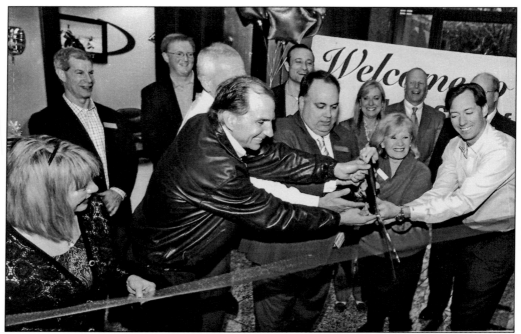

The newly elected members of Brookhaven City Council cut the ribbon for the first city hall on December 17, 2012. Holding the scissors are, from left to right, council members Joe Gebbia, Jim Eyre, J. Max Davis (mayor), Rebecca Chase Williams, and Bates Mattison. The first temporary city hall was located in the neighboring city of Dunwoody, where the city offices were housed until space became available a year later in Brookhaven. (Photograph by John Dickerson.)

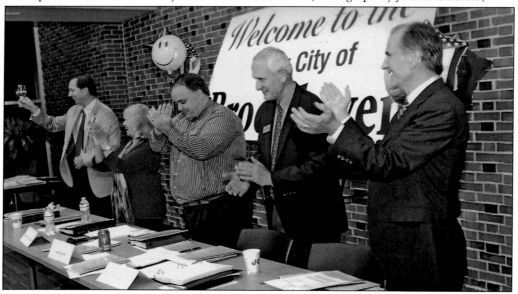

Brookhaven became the newest and largest city in DeKalb County in 2012 after the state legislature granted citizens the right to vote on creating a new city. It was a lively campaign, as citizens debated the pros and cons of creating a new municipality. The motion passed with 55 percent of residents voting "yes." (Photograph by John Dickerson.)

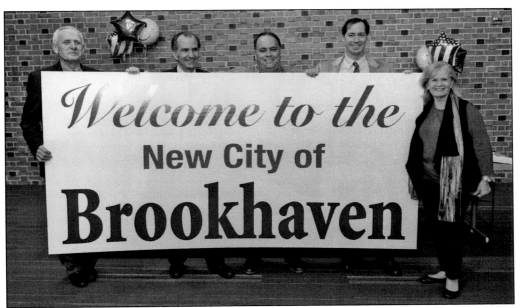

Members of the new city of Brookhaven City Council and the new mayor hold a celebratory banner in 2012. Pictured are, from left to right, Jim Eyre, Joe Gebbia, Mayor J. Max Davis, Bates Mattison, and Rebecca Chase Williams. (Photograph by John Dickerson.)

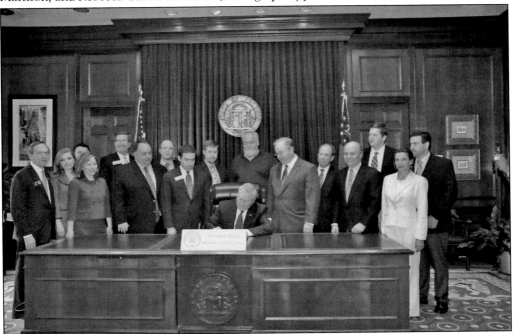

In April 2012, Georgia governor Nathan Deal signed the bill creating a charter for a city of Brookhaven that called for a voter referendum on July 31 of that year. Pictured at the signing are the bill's sponsors, state representatives Mike Jacobs (R-North DeKalb), Tom Taylor (R-Dunwoody), and state senator Fran Millar (R-Dunwoody). Also pictured are members of "Brookhaven Yes" and other supporters of the proposed city of Brookhaven. (Photograph by Rebecca Chase Williams.)

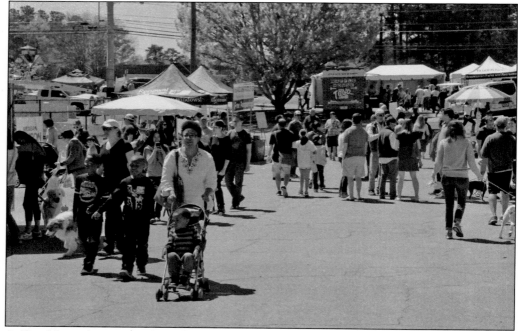

As Brookhaven's signature festival, the Cherry Blossom Festival attracts 14,000 to 20,000 people each spring. With live music, an arts show, a children's village, a stunt dog show, classic cars, a 5K race, and lots of food, the festival features something for the whole family. (Photograph by Rebecca Chase Williams.)

Blackburn Park, with its large open spaces, is a popular place for city gatherings including food-truck events, a Christmas tree lighting, and live music concerts like the one shown here. (Photograph by Rebecca Chase Williams.)

Brookhaven celebrated the city's first Arbor Day by planting a cherry tree in front of city hall. City council members, the city manager, the city arborist, and the Japanese consul general joined in the planting. Brookhaven has been awarded a Tree City USA distinction for its efforts to preserve and expand its lush tree canopy. (Photograph by Rebecca Chase Williams.)

Within a few months of becoming a new city, Brookhaven formed its own police department. At this ceremony in 2013, about 40 officers were sworn in, and responsibilities for policing Brookhaven were officially transferred from DeKalb County. Better police protection was one of the main reasons residents voted to form their own city. (Photograph by Rebecca Chase Williams.)

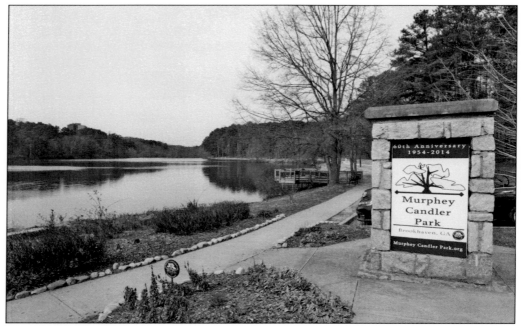

Murphey Candler Park added this sign in 2014 to celebrate the park's 60-year anniversary. This photograph was taken alongside Candler Lake, named for Scott Candler, who was instrumental in the development of the park. The park itself is named for Scott's father, Charles Murphey Candler. (Photograph by John Dickerson.)

The popular Duck Duck Goose 5K race is a yearly event during which runners circle beautiful Candler Lake and run through the woods of the 250-acre Murphey Candler Park to raise money for the park conservancy. (Photograph by Rebecca Chase Williams.)

BIBLIOGRAPHY

Bisher, Furman. *Peachtree Golf Club*. Atlanta: Peachtree Golf Club, 2004.

Craig, Earl Jr. *A Century in North DeKalb*. Chamblee, GA: First Baptist Church of Chamblee, 1975.

Davis, Ren. *Caring for Atlanta: A History of Crawford Long Hospital*. Atlanta: Wings Publishers, 2003.

Garrett, Franklin M. *Atlanta and Environs: A Chronicle of Its People and Events*. Vol. 1. Athens: University of Georgia Press, 1969.

———. *Atlanta and Environs: A Chronicle of Its People and Events*. Vol. 2. Athens: University of Georgia Press, 1969.

Gwin, Yolande. *Yolande's Atlanta: From the Historical to the Hysterical*. Atlanta: Peachtree Publishers Ltd., 1983.

Kaufman, David R. *Peachtree Creek: A Natural and Unnatural History of Atlanta's Watershed*. Athens: University of Georgia Press, 2007.

Knettel, James Kevin Atlanta's Camp Gordon, 2011.

Price, Vivian *The History of DeKalb County, Georgia: 1822–1900*. Fernandina Beach, FL, 1997.

Rhea, Amber. *Educating DeKalb: Midcentury Elementary Schools*. Atlanta: Georgia State University, 2013.

DISCOVER THOUSANDS OF LOCAL HISTORY BOOKS FEATURING MILLIONS OF VINTAGE IMAGES

Arcadia Publishing, the leading local history publisher in the United States, is committed to making history accessible and meaningful through publishing books that celebrate and preserve the heritage of America's people and places.

Find more books like this at
www.arcadiapublishing.com

Search for your hometown history, your old stomping grounds, and even your favorite sports team.